TRURO
THROUGH TIME
Christine Parnell

AMBERLEY PUBLISHING

Acknowledgements

My thanks to all those who helped me in any way to complete this book especially those who have found photographs and done their best to remember names and information. If I have inadvertently left anyone out please accept my apologies. Mandy Adison, Clive Benney, John and Margaret Colston, Susan Coney (née Phillips), Wendy Dawe, Viv Drew, Jenny Dunford,Mary Dunstan, Sheila Harris, Viv Hendra, John James, Caroline Jones, Valerie Littleton (née Penny), Vaughan Magor, Tony Mansell, Clarice Mortensen Fowler, Barbara Pascoe (née Pill), Sheila Richardson, Daphne Stearn, John and Sheila Trembath, Avril Wilson and my cousin Graham Coad.

For David and Tamsin and their families

First published 2010

Amberley Publishing
Cirencester Road, Chalford,
Stroud, Gloucestershire, GL6 8PE

www.amberley-books.com

Copyright © Christine Parnell, 2010

The right of Christine Parnell to be identified as the Author of this work has been asserted in accordance with the Copyrights, Designs and Patents Act 1988.

ISBN 978 1 84868 594 9

British Library Cataloguing in Publication Data. A catalogue record for this book is available from the British Library.

Typeset in 9.5pt on 12pt Celeste.
Typesetting by Amberley Publishing.
Printed in the UK.

Introduction

Truro, the administrative centre of Cornwall today has a long and varied history. The town grew up on the trade route from the Gannel to the Fal, nestled between two rivers, the Kenwyn and the Allen. It is possible that the word 'Truro' derives from three rivers as there is a third river, the Glasteinan, no more than a trickle these days which meanders down under the Trafalgar area. Pydar Street is probably the oldest street in the town and led travellers down to a settlement near a Cornish cross that is believed to have been erected by the Dominican friars who settled in Truro *c.* 1250. Truro once had a castle which was in use during the tempestuous reign of King Stephen and it is highly likely that this castle was built on the ruins of a much earlier earthwork. It was Richard de Lucy, a henchman of Alan of Brittany Earl of Cornwall who was credited with granting Truro its first charter *c.* 1153 although whether he ever came to Truro is not known.

In 1327 Truro became a stannary town which would have improved its prosperity with the twice yearly coinages at midsummer and Michaelmas and in 1351 the Duke of Cornwall's steward was instructed to build or buy a house for the coinage. The coinage hall was built at the end of Middle Row where it stayed until it was eventually demolished in the mid nineteenth century. The town had its ups and downs and was actually set on fire in 1404 in a fight with the French who thought nothing of coming up the Truro River!

During the Civil War Truro declared for the Royalists and young Prince Charles came to Truro for part of the winter in 1645. In 1642 Truro became home to the Royal Mint for a short time as Exeter was in Parliamentarian hands.

Truro has many famous sons, some born here, some who were sent here to be educated at the Grammar School which was founded in 1549. Among the former are, Humphry Davy and Goldsworthy Gurney. Among those born in Truro are Richard and John Lander who traced the course of the Niger, Henry Bone the enamellist and miniaturist, Samuel Foote the actor and satirist and Henry Martyn the missionary.

Truro has a fine wide main street in Boscawen Street as when Middle Row was pulled down it was not replaced. The Municipal Buildings is an Italian style building designed by Christopher Eales and houses the Hall for Cornwall on Back Quay. Another imposing building in Boscawen Street is the Coinagehall which occupies the site of the old coinage hall and was built in Tudor style as a bank. There are many Silvanus Trevail designed buildings although perhaps the most famous, the post office in High Cross was demolished some years ago. Walsingham Place is attributed to Philip Sambell and he was also the architect of other buildings including the museum and Truro Methodist Church, all remarkable as he was a deaf mute.

In 1877 Truro was granted city status and the old St. Mary's church was pulled down to make way for the new cathedral. The south aisle was retained however and still serves the people as their parish church today.

Obviously with such a long history many changes have taken place over the years and yet if you know where to look there are still ancient reminders of the town's past. The granite cross in High Cross is now restored to its old site and stands where it stood 700 years ago, the face of one of the abbots of the friary gazes out from a carved stone over what was once the friary graveyard and a millstone lies in the ground in an alleyway. It is more recent changes however that you will find here, buildings, roads and people captured in a moment in time by the wonders of photography and matched with an image of today.

In time these modern photographs will be the historic records for Truronians of the future to gaze at in wonder.

Christine Parnell 2010

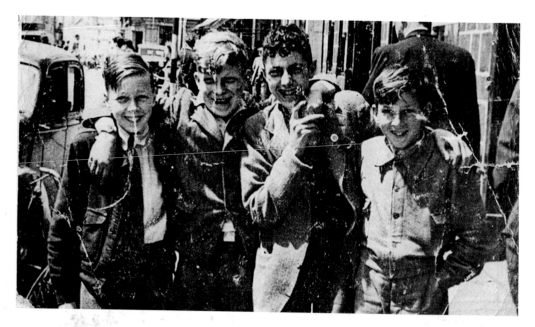

Boys on the Loose
Four boys from the Technical school c. 1940 enjoy some time away from the classroom and are snapped outside the Red Lion. From the left they are, L. Sandercock, J. Trembath, W. Wright and S. Preen.

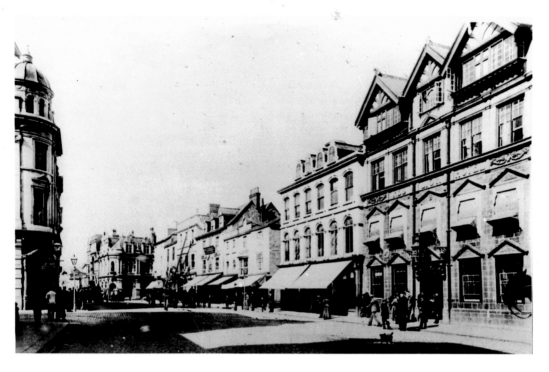

Boscawen Street

On a sunny day in Boscawen Street *c.* 1900 the windows of the Red Lion are open and the shop windows are sheltered by blinds. The additional storey has not yet been added to the premises on the corner of Cathedral Lane but can be clearly seen in the modern view next to the rooms that formed the annexe to the Red Lion.

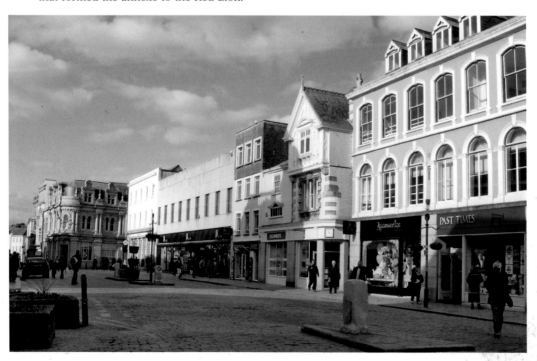

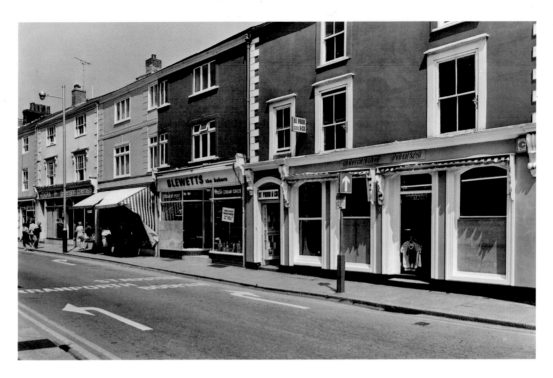

Lower Lemon Street

Not much has changed in Lower Lemon Street over the years except for the new shops that come and go. Whereas the road was laid out to carry two lanes of traffic in the 1960s that would be very difficult nowadays as the flower beds known as 'tank traps' have sprung up all over the city and act as traffic calming measures. Nevertheless the City Council Parks Department keep them well stocked and the flowers are always a delight.

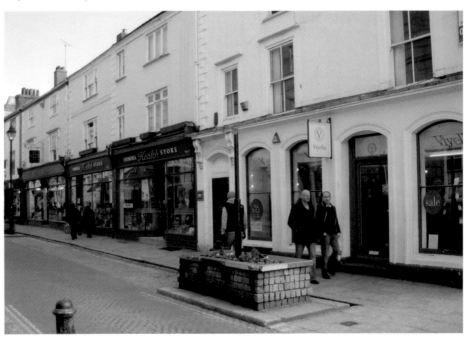

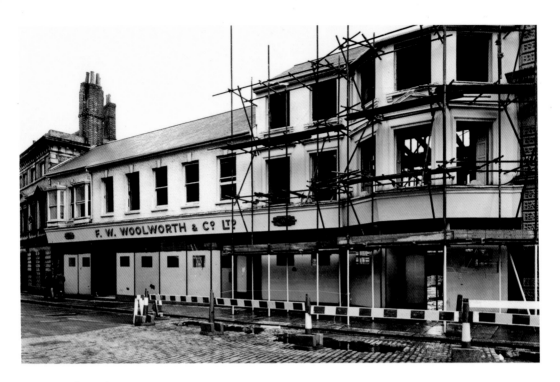

Woolworths

Back in 1977 when the premises of F. W. Woolworth was being upgraded no one dreamed that by 2010 all the Woolworth stores in towns would be gone and only on line shoppers could buy from them. For a while it was not known whether any other store would open in this prime spot in Boscawen Street opposite the war memorial but then Poundland came along and is a popular place for bargain hunters.

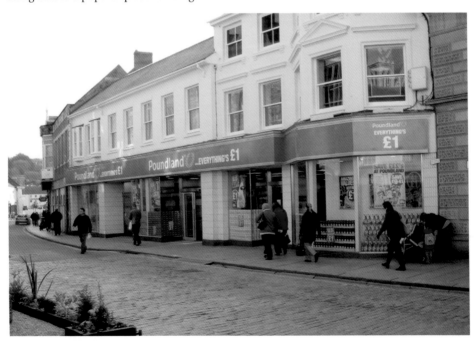

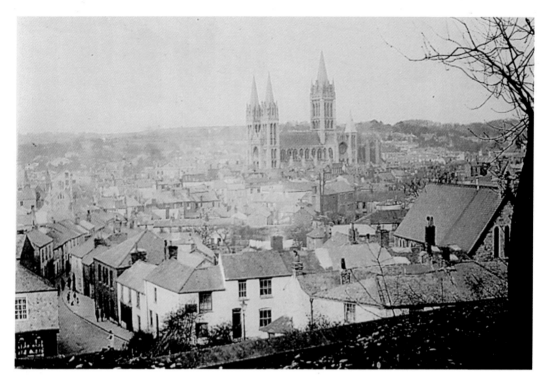

Calenick Street

Looking down Calenick Street from the grounds of the City Hospital in the 1930s we see just how many cottages there were lining the road. These have now gone and businesses have taken over. The road is quite busy as it leads to the Moorfield car park.

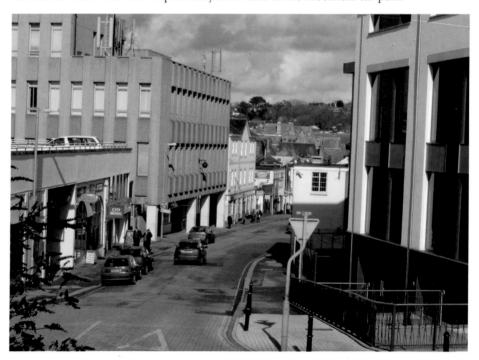

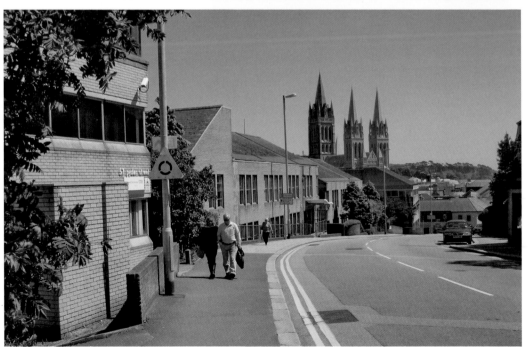

The Road into Town
Pydar Street is one of the oldest streets into Truro and was once known as Strete Pydar. It led pilgrims and merchants who had entered the county by the River Gannel down into the town to continue their journey on the River Fal. Fortunately the cathedral still has three spires and is instantly recognisable whereas the rest of the road is very changed from the old view of it in the 1950s.

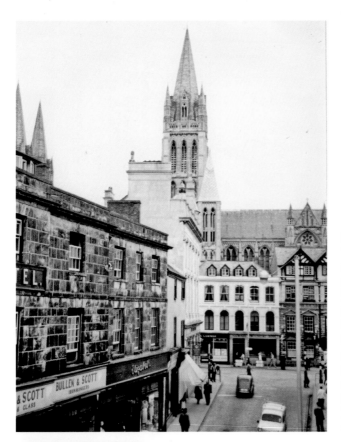

Lower Lemon Street

The street looks quite drab in the 1950s. It is more cheerful now that the Royal Hotel has had the soot cleaned off the stonework and we can see from the modern photograph that the shops on the right are brightly painted. The loss of the Red Lion in 1967 takes away much of the character in the centre of Truro, the pseudo Tudor Co-op will never match up to the old coaching inn.

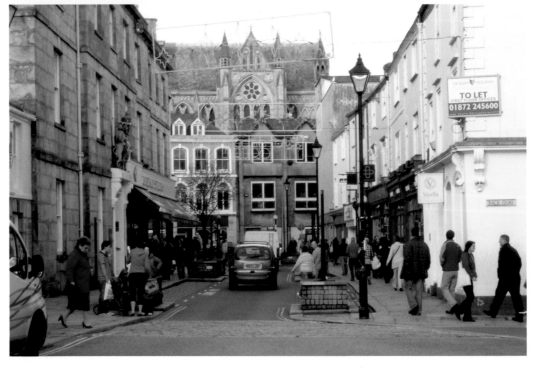

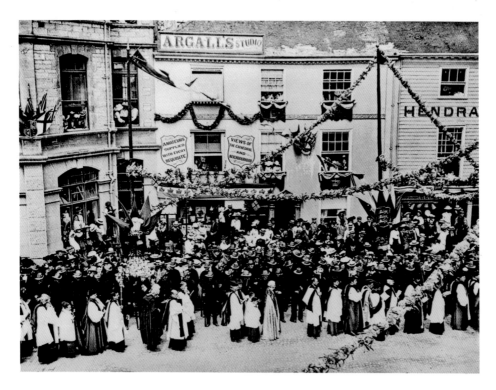

King Street

Truro is decorated with bunting and crowns probably coronation celebrations for Edward VII. The old post office was built in 1886 and Argalls the photographer and Hendra the plumber have premises in High Cross in the area of today's post office. With the post office behind us this 2009 photograph shows one of Jack's Cows which were dotted all round the town to raise awareness and money to keep the Hall For Cornwall in a good state of repair.

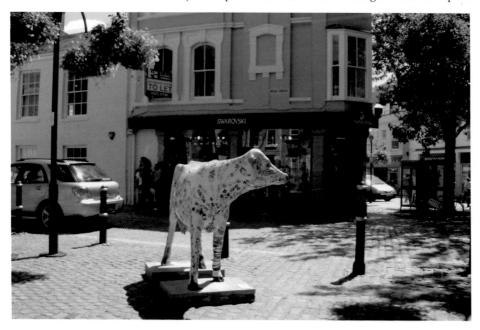

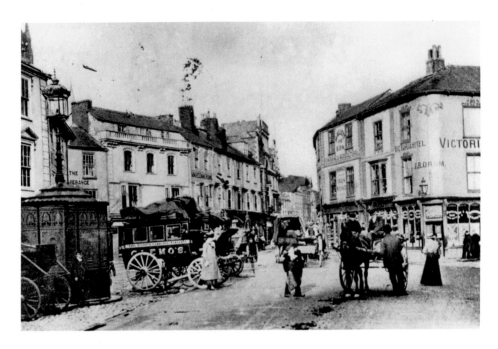

Victoria Square

How busy Victoria Square looks in this old photograph *c.* 1880. It was one of the places where the horse buses from the outlying district waited until it was time to leave. The old iron duke toilet was there for many years after this photograph was taken but has gone now. The reindeer were an attraction in the square at the beginning of late night shopping in 2009 just as they had been the previous year.

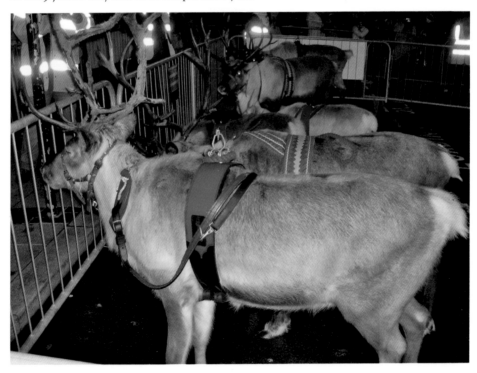

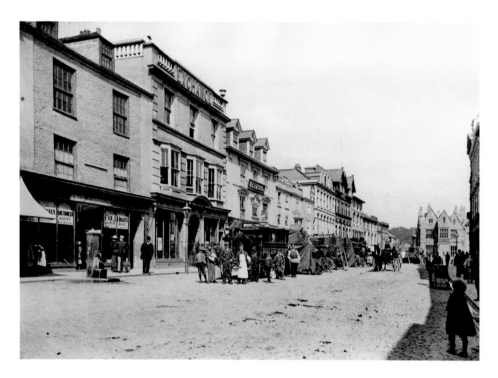

Town Centre

Boscawen Street in the early part of the twentieth century regularly had carriages and horse buses parked down the centre of the road. The corn exchange later gave way to the Gas Showrooms and is now British Home Stores. Many people dislike the bollards and tank traps that have sprung up all over town but nevertheless the tank traps look very attractive and add to the overall appearance of the town especially when the Britain In Bloom judges arrive.

Pearson's Ope

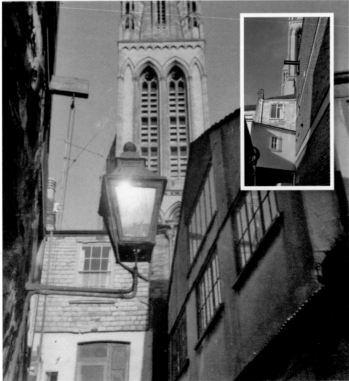

Just before Christmas 2009 a new 'old fashioned' sweet shop opened in High Cross beside Pearson's Ope. From the other side of the arch in the ope way the gas lamp in the old photograph gives a really old world feel to the little passage way that can be used as a short cut between Boscawen Street and High Cross. The inset view is the exit into High Cross from the Ope today.

Tippets Backlet
This little lane running between River Street and The Leats is very different today from the way it used to be and it could well be unrecognisable to anyone beamed down from fifty years ago. These days it is lined with shops and a café but in the past there were many old cottages. Since the top of the backlet has been opened up, a narrow sharp turn has been included making it seem like a different place.

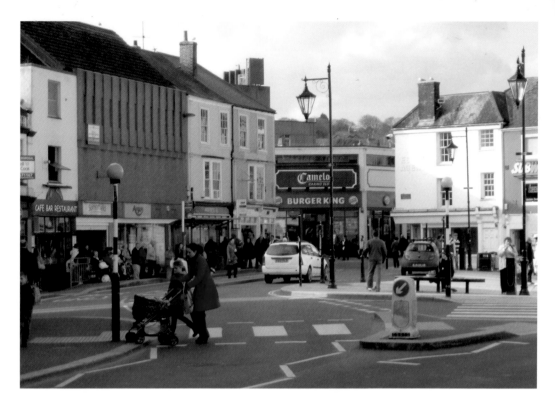

Victoria Square

The most noticeable change in Victoria Square in 2010 is that there is a new road layout and all the parking that was available in the 1970s has gone. Of course the shops and cafés are all different as well but this area which was the site of the old west bridge in mediaeval times is still recognisable.

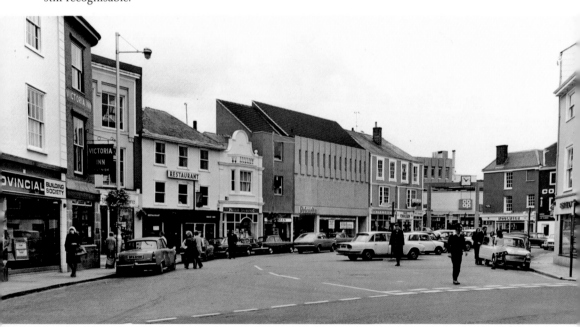

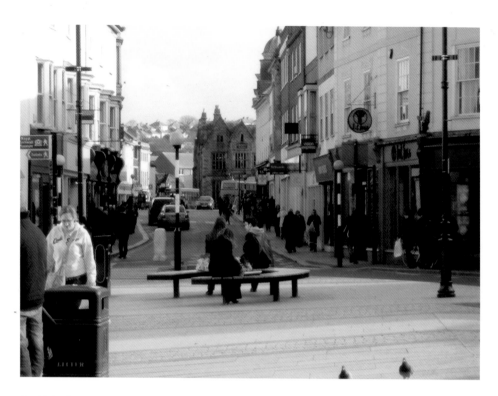

St Nicholas Street

St Nicholas Street is still full of shops and often to be found thronged with people. Radmore's Dining Rooms in the old photograph have given way to a bench outside Rowe's Bakers where it is convenient to sit and have lunch but no longer will you find people standing in the road to have a chat!

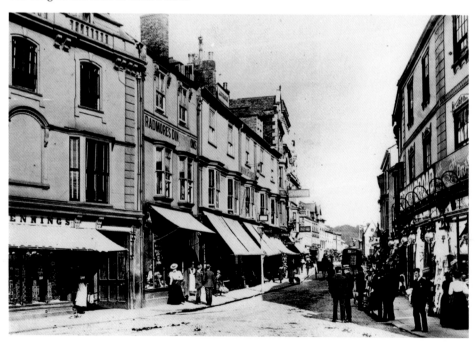

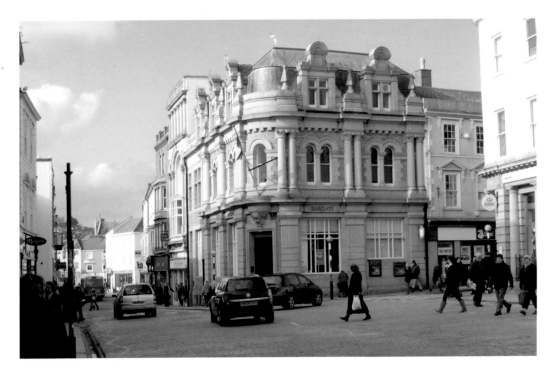

St Nicholas Street

The pump in Boscawen Street has gone and Pearson's the Jeweller is no more but the junction of Boscawen Street is little changed. A Western Greyhound bus disappears towards Victoria Square whereas the usual method of transport of the day in the old view *c.* 1900 is the horse and cart that rumbles away from the camera.

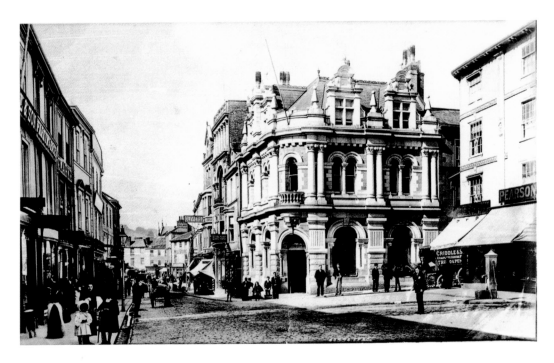

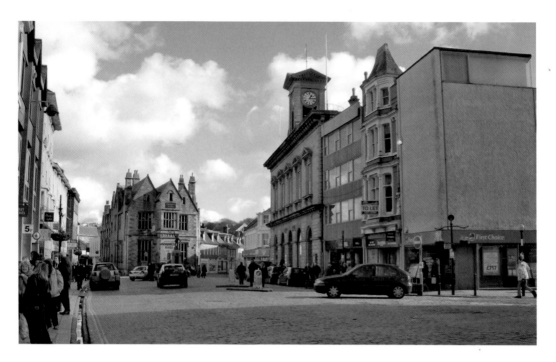

Boscawen Street

Three things are noticeably different in the modern view of Boscawen Street to that of the older photograph although thankfully not much has changed. London House has had the windows covered over with a mosaic tile façade, the war memorial is in position, (unveiled in 1922) and the town clock has a white face not a black one. The fire on 11 November 1914 destroyed the clock tower and the new clock had a facelift!

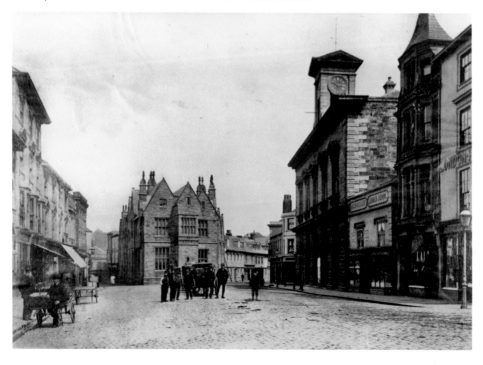

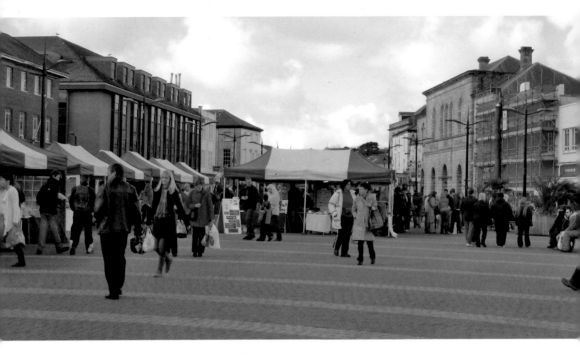

Saturday Afternoon on the Piazza

This useful space between Lemon Quay and Back Quay has a name that is unpopular with many locals however it is well used for market stalls etc. In the older photograph taken before the river was covered Lemon Bridge can be seen and it is noticeable that the premises of Gill's the drapers was situated where the 1930s building which was for many years F. W. Woolworth is now.

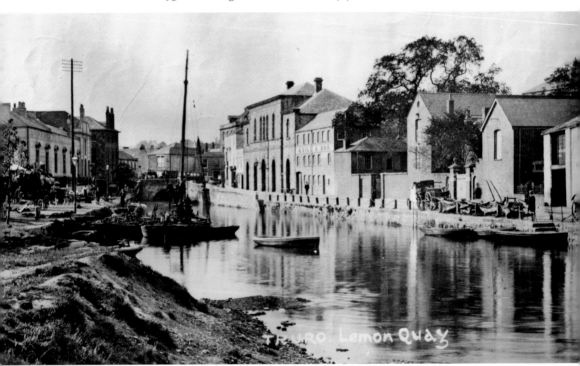

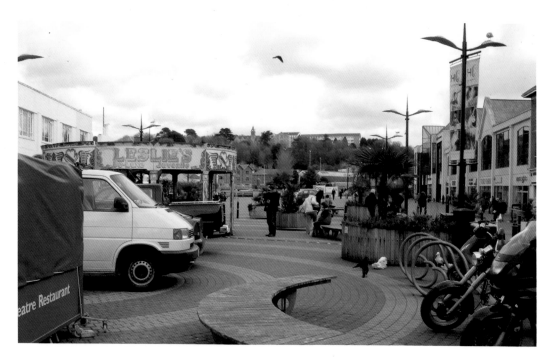

Back Quay

A merry-go-round, planters and vehicles adorn what was once open river. In summer tables and chairs are set out for the cafés to serve their customers and the benches that wave over the area are useful to shoppers. The photograph of the early 1900s was taken from Lemon Bridge and gives us a wonderful insight into life by the river with boats moored at Back Quay and a marvellous old car on the Lemon Quay side.

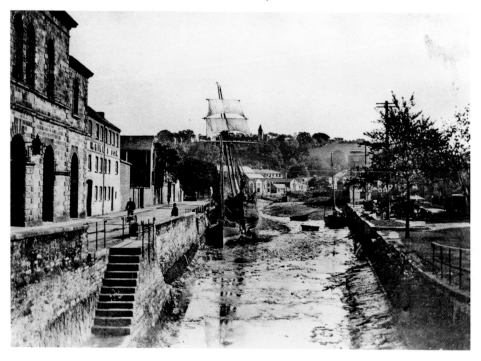

All Change

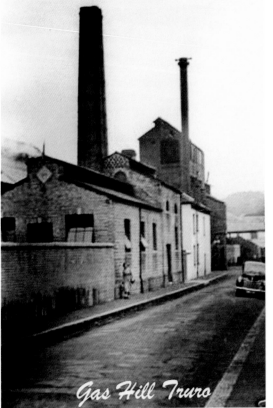

Gas Hill Truro

This modern photograph of Gas Hill has nothing to show except a small car park and pleasant views of the river through the trees before there are too many leaves to see through them. The picture was very different in the 1950s when John Colston took a photograph of Gas Hill. The retort of the gas works dominated the road overlooking the cottages where several families lived and enjoyed the community spirit of the area.

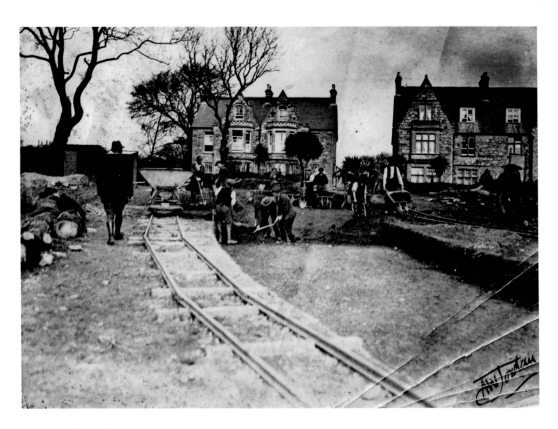

Hendra Hill

The building of a road up through Hendra was quite an undertaking and even a track for the skip had to be built up the steep incline. Today the road through the rows of houses is well used and has been peppered with 'sleeping policemen' to keep the speed of the motorists down.

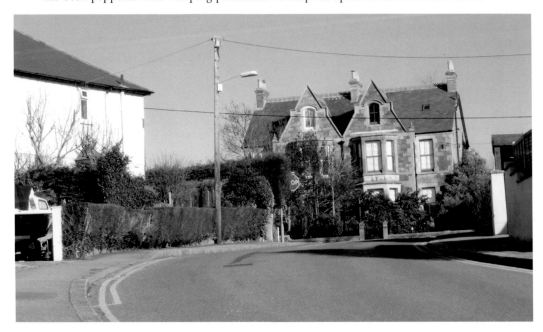

Chainwalk

Our old photograph shows a gentleman in riding gear and a man in a bowler hat, possibly a groom and it appears that he is the one who has to fetch the horse. Mr Body strolls down the lower end of Chainwalk and as can be seen from the inset picture farther up the lane the chains still swing on their granite posts. The meadow for the horse has gone and is now covered in houses.

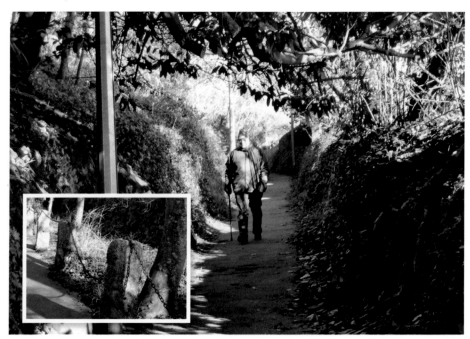

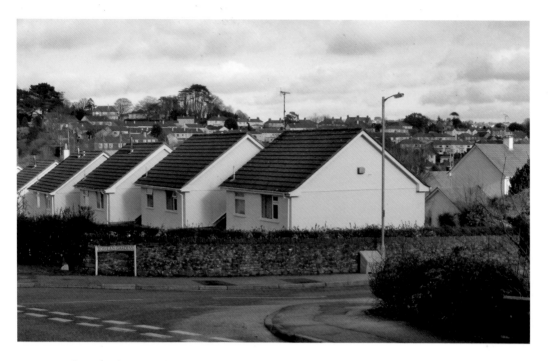

Housing Development in Mr Martin's Field

The houses known as Bosvean Gardens now sit on the field that was once Mr Martin's orchard. Many children have helped themselves to an apple or even a turnip when having hunger pangs while out playing across the road from the orchard in Rotten Woods. The photograph by John James shows the field with a blanket of snow.

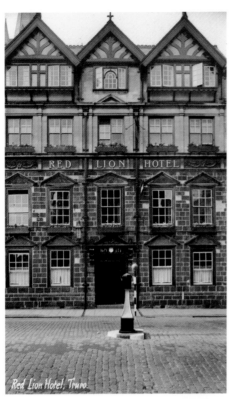

Red Lion Hotel, Truro.

The Red Lion

The Red Lion was built as a private house in 1671. Later it became a much respected hotel and was found on its demolition in 1967 to have been built on the remains of a Tudor house. The loss of such a building is still regretted by many. Will anyone ever be so fond of the supermarket edifice that has replaced it?

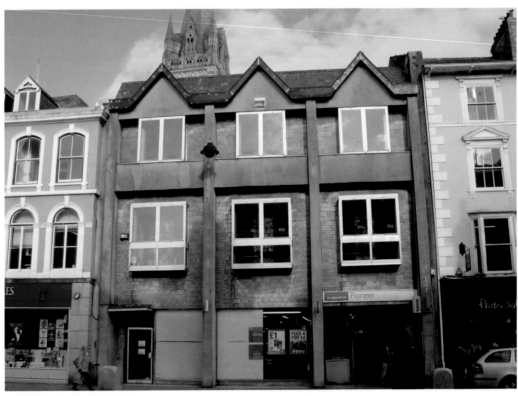

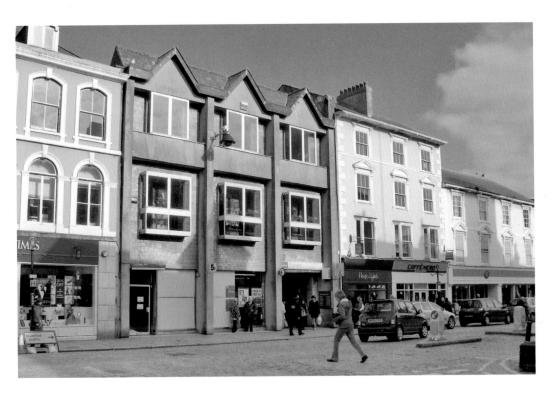

The Red Lion

The Co-op definitely does not have the charm that the Red Lion had. Built as a town house for the Foote family in 1671 it was bought by Edward Giddy in 1769 and he shut up the old Red Lion farther along the street and moved into his new premises. A runaway lorry in 1967 signalled the end of the beautiful building and a modern edifice in roughly the same style has taken its place.

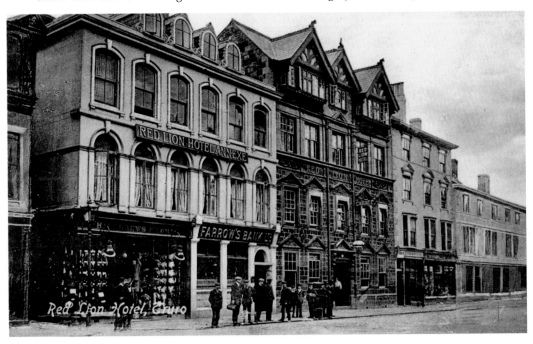

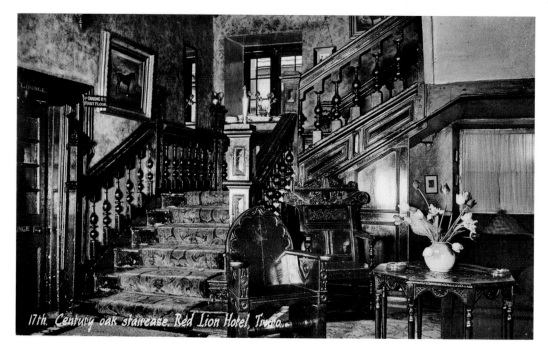

17th. Century oak staircase. Red Lion Hotel, Truro.

What a Contrast
The inside of the Red Lion with the seventeenth-century staircase and ancient furniture will never be seen again. Many a good dinner has been served in the first floor dining room and the wallpaper and pictures which look so dated now were once the epitome of elegance. The Co-op supermarket is a far cry from the Red Lion but is bang up to date as it has been decorated with footballs for the World Cup 2010.

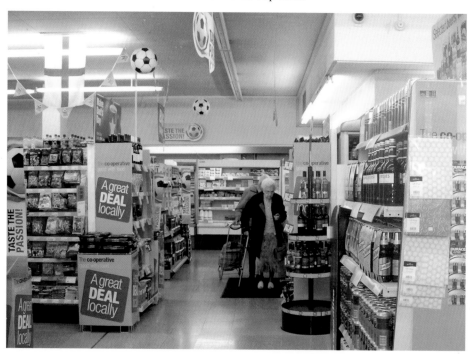

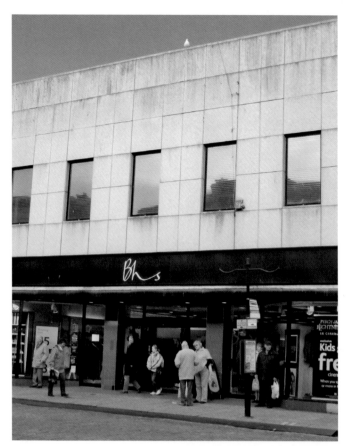

Seeing Stars
This is not the most elegant building in town but one which was built for Littlewoods and is now British Home Stores. It is on the site of a public house called the Seven Stars but that building was demolished in 1883 to make way for the Corn Exchange.

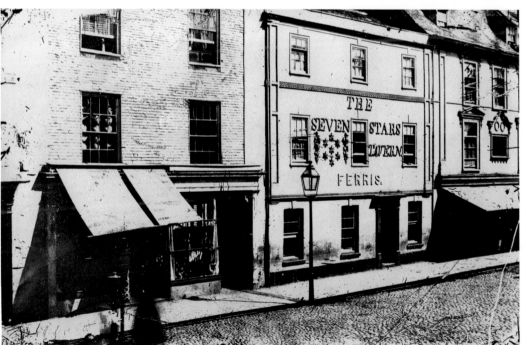

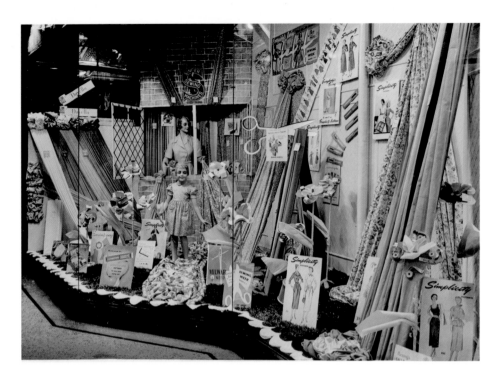

Dressmaker's Dream

The fabrics and dressmaking patterns in the window of Roberts arcade in the late 1950s were very attractive at the time. The arcade was erected in 1928 and modernised in 1932. An interesting window today is the House of Fabrics in Lemon Street although these materials are for curtains and upholstery. The railings add interest to the picture. Most of the railings in Lemon Street were taken away for the war effort but all for nothing as they were never used.

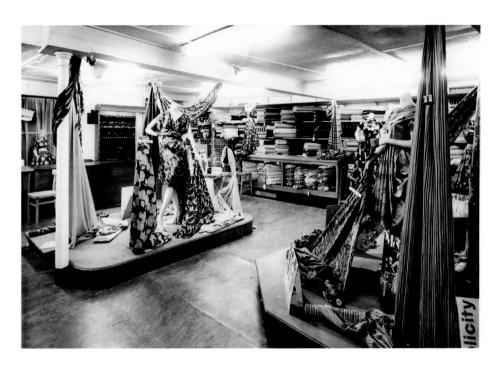

How to Choose!

In the 1950s W. J. Roberts in Boscawen Street catered for all the needs of the sewing and knitting public with wonderful displays of materials and wools complete with massive pattern books which could take ages to trawl through. Roberts may be gone but this year is the 25th anniversary of Truro Fabrics who have materials, wools and patterns galore to tempt their customers.

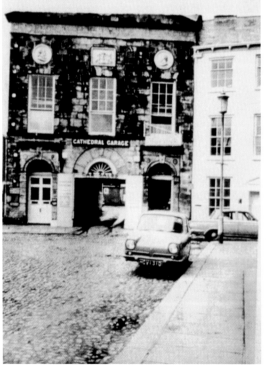

The Assembly Rooms

Today the building that once housed the Assembly Rooms is Warrens bakery and coffee shop and is a really elegant addition to the city. Back in the days when it was a garage the beauty of the façade was hidden beneath a layer of soot.

The Pottery

It is believed the
Dominican Friars
started the pottery
soon after they came
to Truro *c*. 1250. Over
the years it had mixed
fortunes but by the
1920s the business
had Mr W. C. Lake in
partnership with the
owner, Mr Tucker and
Lake's Pottery was
famous until it was
sold as Truro Pottery
in 1984. The Baptist
Chapel now stands
on the site having
moved from the Philip
Sambell designed
building next to the
museum.

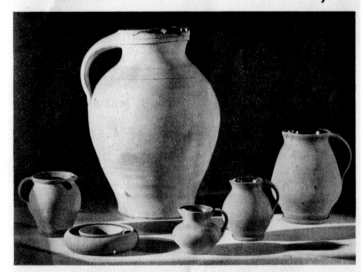

LAKE'S Cornish Pottery

Chapel Hill, Truro

33

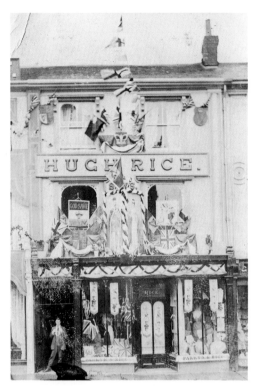

14 Boscawen Street

The shop remembered by many as Hugh Rice near the town end of Boscawen Bridge was once called Parkyn and Rice and was situated at number 14 Boscawen Street. By 1902 it was just known as Hugh Rice. These days number 14 is the premises of Burton the outfitters and is seen here in 2008 when people queued for hours to have their copies of *Francesco's Mediterranean Voyage* signed by the author, Francesco Da Mosto in Waterstone's bookshop.

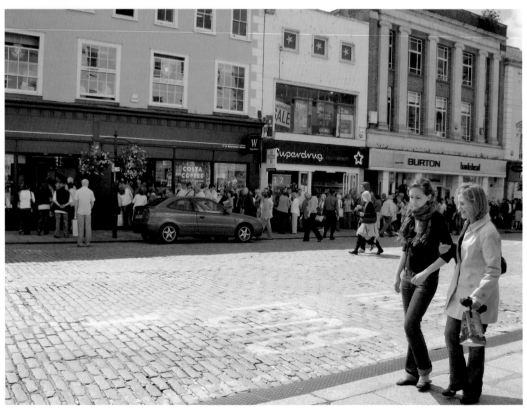

Police Stations

The police station is a familiar sight covered in communication aerials. People are used to the fact that it was built 'back to front' and the corridors that can be seen from the road should be at the back . The previous station had been outgrown but Truro lost an attractive building when it came down in 1974. These days there is a walk in police station in Lemon Street as there is no public access anymore at Trafalgar roundabout.

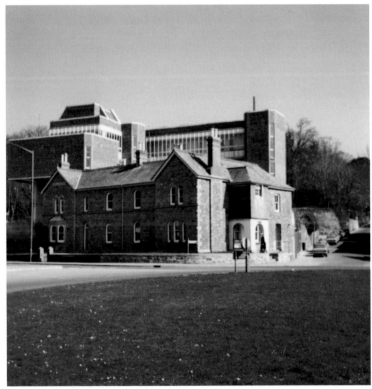

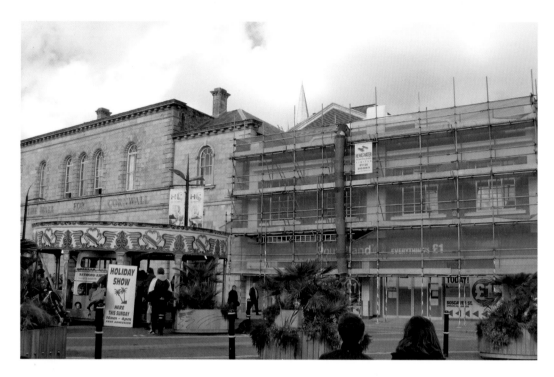

Does Anyone Know the Time?

It is difficult to get a 2010 view of the town clock from the back of the Municipal Buildings as although the tower of the cathedral is more or less in the right place, the clock is completely hidden by the new fly tower of the Hall for Cornwall. In the view taken just after the fire on 11 November 1914 the clock would have been clearly visible. The inset shows it as it is today from Boscawen Street.

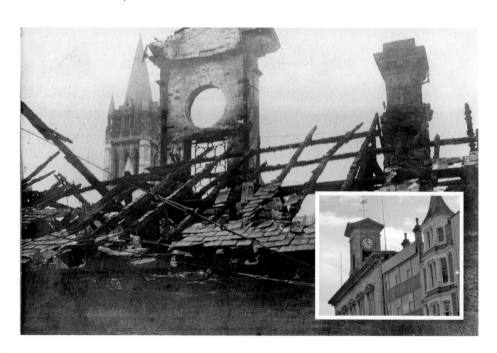

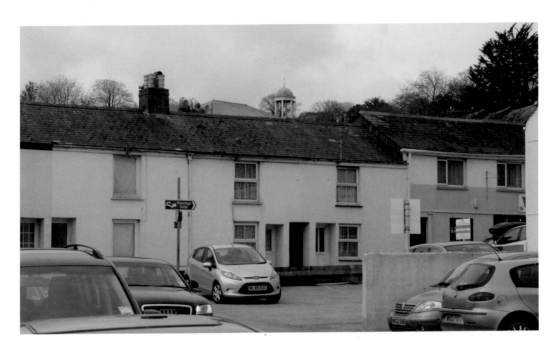

An Old Truro Cottage

These cottages in Fairmantle Street are typical of those that once existed all over Truro. These days many of those that survive have been turned into offices. The drawing was done in 1958 by J. R. Stephens and is entitled 'Gran Williams' Kitchen'. Gran Williams lived in one of the now demolished cottages in Tabernacle Street, where Truro Glass is now and the kitchen with the old Cornish range and the settle remained unchanged until the cottage was pulled down.

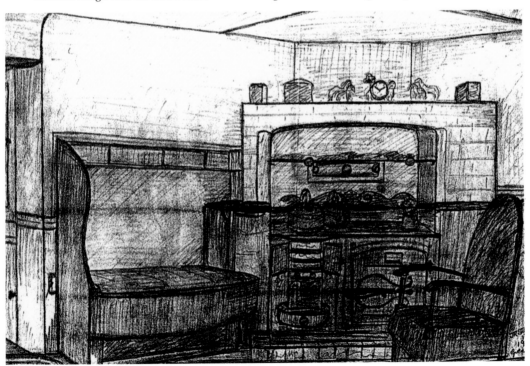

City Hospital

The original City Hospital building can still be seen in the newer view but all the other part of the building has disappeared. Housing has now taken over from health care in this part of the complex but the new Truro Health Park is just up the road. Work has been going on for several years and the difference between the photograph of 2007 and 2010 is noticeable.

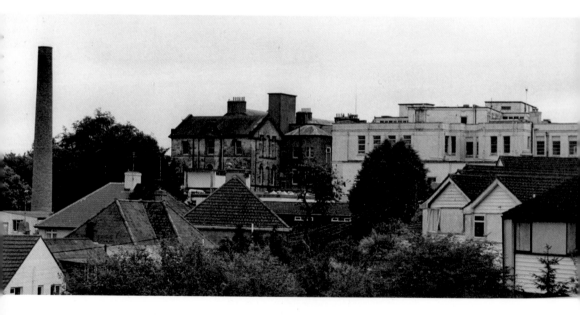

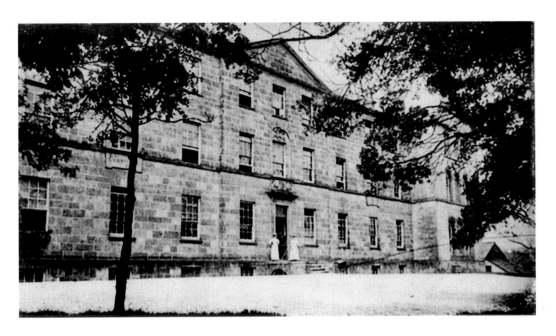

City Hospital

The front of the City Hospital was not often seen by patients and visitors in recent times as the usual entrance was at the Infirmary Hill side of the building but these two ladies predate that era. The building is undergoing much work at the present time so the view taken in 2010 is of the Kenwyn Street side. The main hospital these days is at Treliske, however the new health centre for Truro is on part of the old hospital site.

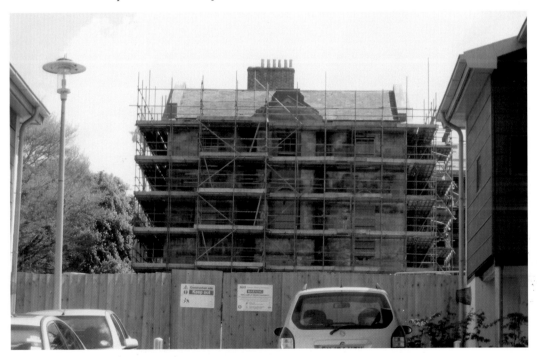

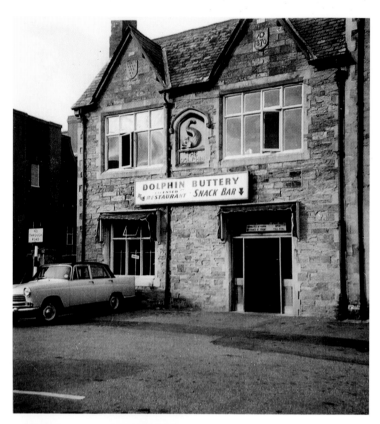

Dolphin Buttery

The Dolphin Buttery was on the site of the Fighting Cocks Inn where Richard and John Lander were born. The inn was called The Dolphin in the 1830s and the carved dolphin is visible on the wall. Being a narrow street, progress required road widening and the old building was demolished. The dolphin is now displayed opposite Trennick Mill. The new road is shown from the other direction with the bus station behind the site of the Dolphin Buttery.

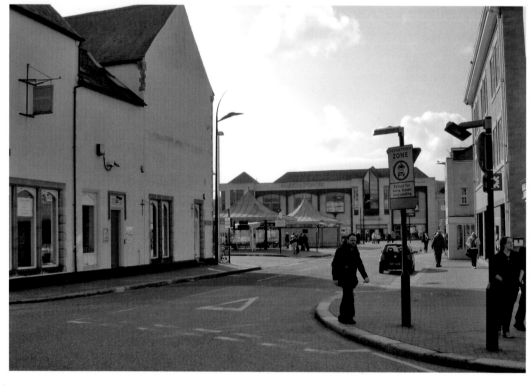

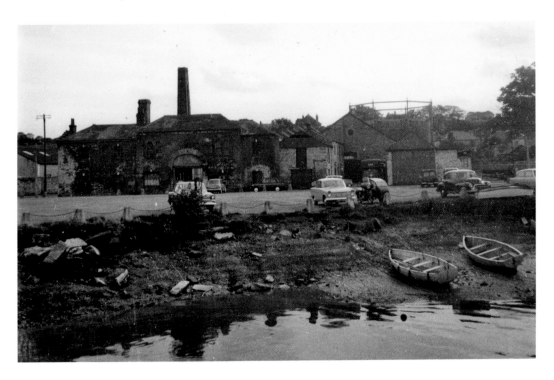

Newham

It is not always easy to pinpoint exactly where an old building once stood when the roads and buildings have been changed. The old gasometer was in the Newham area of Truro and although many people deplore change perhaps the modern view of Marks & Spencer on Lemon Quay is more pleasing to the eye than that part of town in the 1960s.

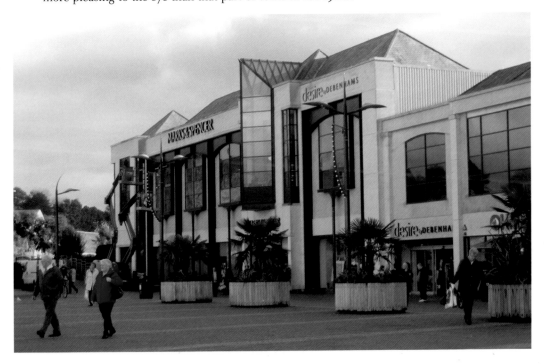

Old School
St Mary's School was demolished in the 1960s and the site is now occupied by Pydar House still regarded by many as the Ministry of Agriculture Fisheries and Food but now DEFRA.

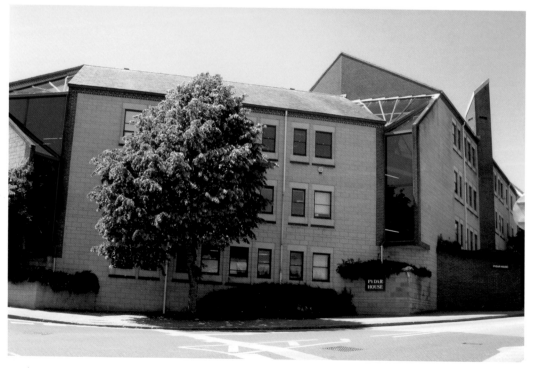

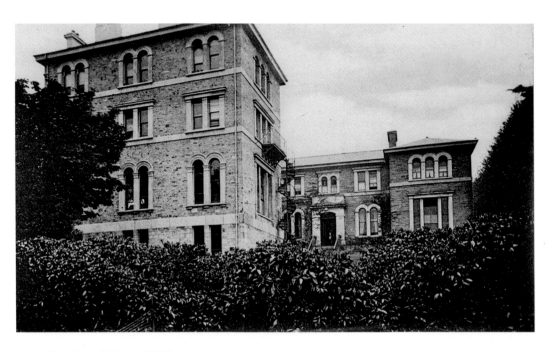

The Top of Mitchell Hill

For many years the teacher training college known as the Dioscesan Training College dominated the skyline of Truro. Next door was St. Paul's Junior School with the infants department at the bottom of Agar Road. Today modern housing occupies the site of the college and school but just across the road is The Rising Sun Inn a long standing feature of this area.

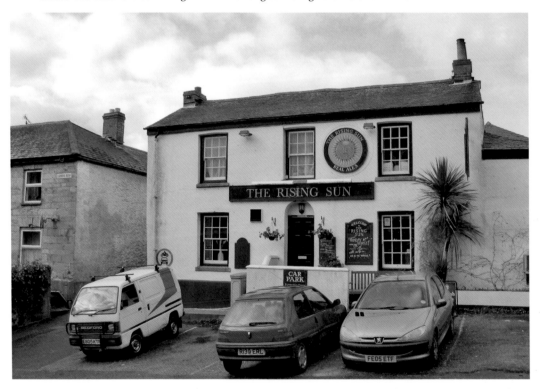

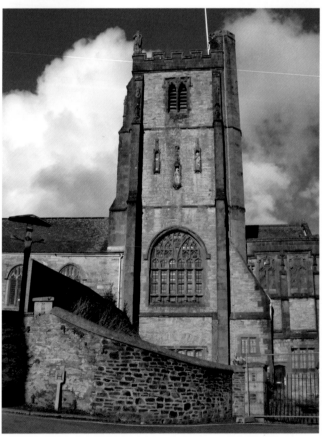

St Paul's Church
John James and Michael Geach stand by the lectern in St. Paul's Church in happier times. The church is now closed due to the condition of the building and meetings are being held to try to find an alternative use for it. The beautiful lectern is now in the church at Chacewater.

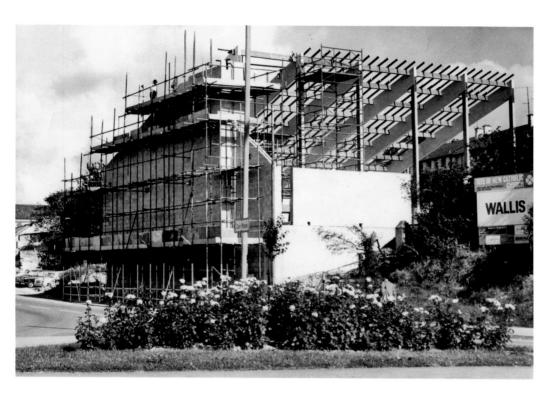

The Roman Catholic Church

In 1972 work was underway to build a new Roman Catholic Church as the one in Chapel Hill that had served the community for so long was too small. The Church of Our Lady of the Portal and St. Piran is a modern building near the Trafalgar roundabout.

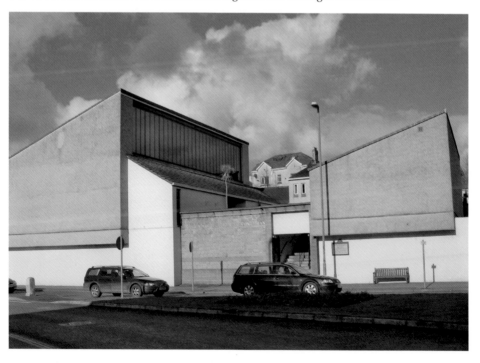

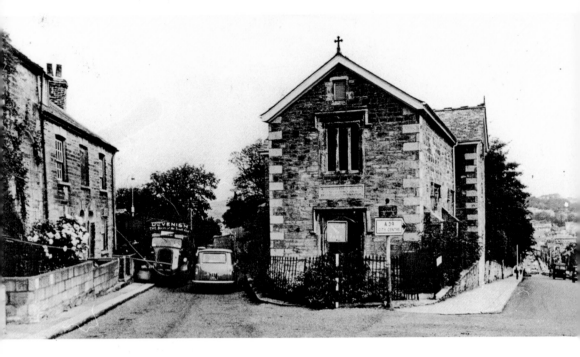

The Old and the New

St. John's Sunday school was a feature at the junction of Lemon Street and Infirmary Hill for many years and the corner looks bare without it. It was a tight squeeze for the car to pass the brewery lorry that was making a delivery to the Daniell Arms. Hopefully there will be no parking problems when the new Truro Health Park opens on part of the site of the old City Hospital.

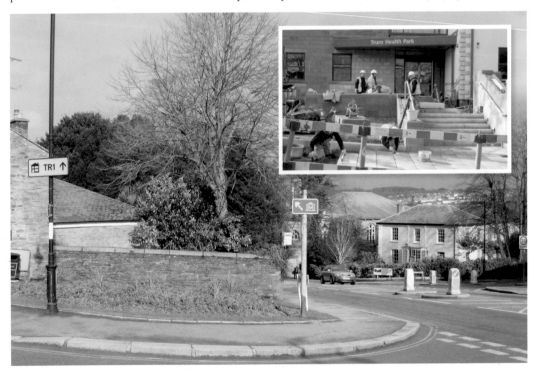

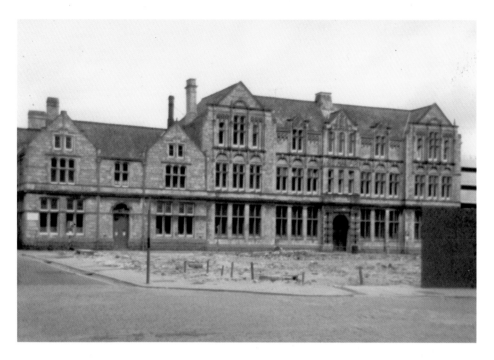

Demolition Site

Prior to the building of what was to be a Marks & Spencer store this was an unusual opportunity to photograph the building that housed the library and at one time the Boys' Technical School. These days it is only possible to photograph parts of it. The building was designed by the architect Silvanus Trevail and endowed by the local benefactor John Passmore Edwards.

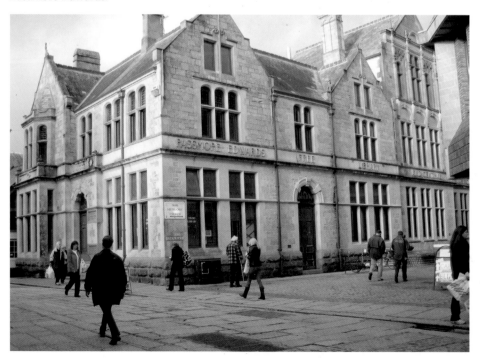

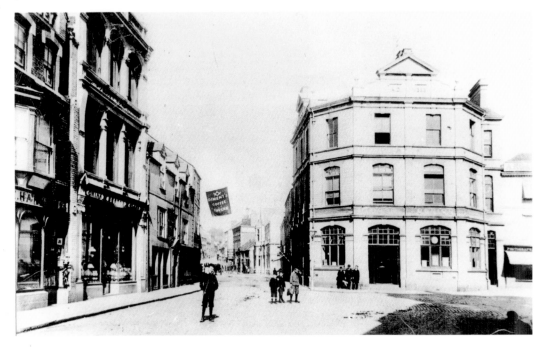

The Post Office

This familiar old picture of Silvanus Trevail's post office and the view up Pydar Street has changed over the years and the current post office is now a few doors along the road in High Cross. The original stone cross can be seen in the new photograph and an information board to help tourists find their way round the town.

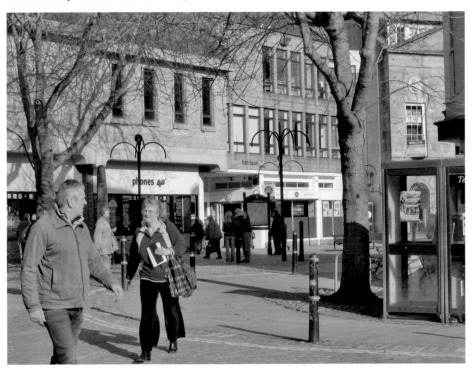

Modern Almshouses

Looking into Union Street in the 1960s we see Charlie Wright's premises on the left. He was a painter and decorator. The modern photograph shows some of the William's Almshouses where the decorator's store once was. The Almshouses were endowed by Henry Williams in 1631 and originally stood on the opposite side of the road in Pydar Street. Mr Williams even provided a meadow for a cow.

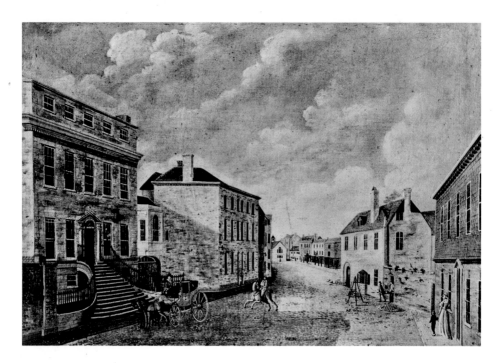

The Beautiful Mansion House

The old engraving shows a carriage drawn up outside the Mansion House and the old Coinagehall on the right. The Mansion House was built for Thomas Daniell in the late 1750s. The modern view of the Tinner's market is the area reached by walking under the archway behind the carriage and is an attractive area in which to shop. The inset is of the building called the Coinagehall today but only because it occupies the site of the old Coinagehall.

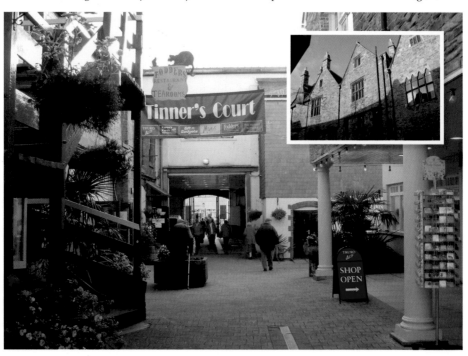

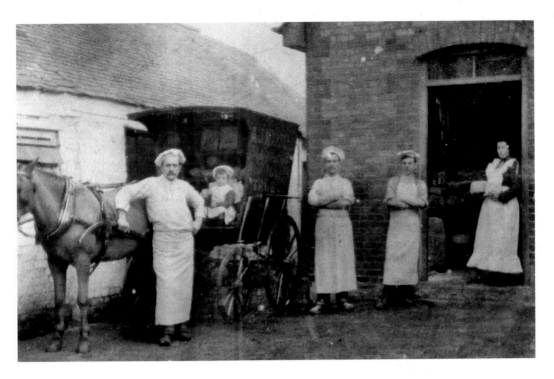

Staff at the Baker's
The staff of A. J. Mansell pose outside the bakery with the forerunner of the motorised van. This was most likely to be in their Old Bridge Street premises. David Johns and Donna Millington welcome customers at Martins in the Pannier Market with a large selection of bread, cakes and pies.

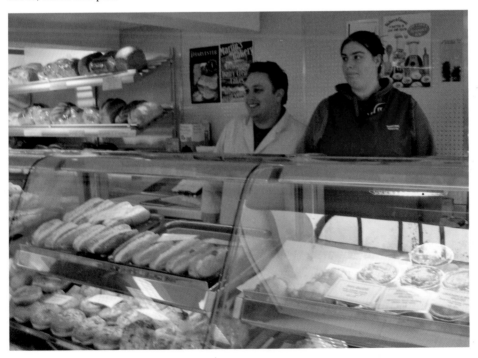

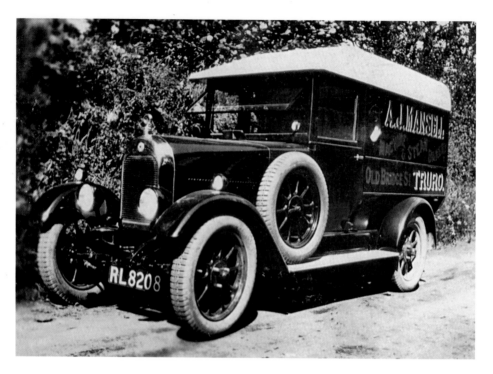

Bakery Vans

The old van which would be an eye catcher today belonged to Alfred James Mansell. He was born in 1865 and died in 1949 and ran his bakery business from the 1890s to the 1930s when he is believed to have sold out to Blewetts. For most of that time his company was based in Old Bridge Street. Many years later Blewetts sold out to Warrens and the Warrens van was snapped in Victoria Square as the driver completed his delivery.

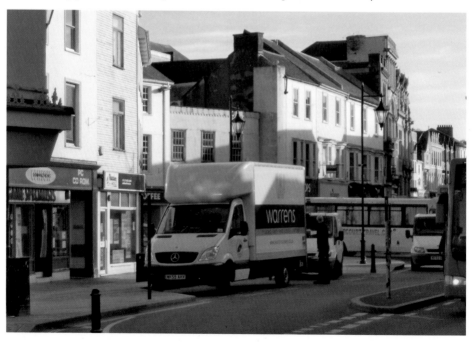

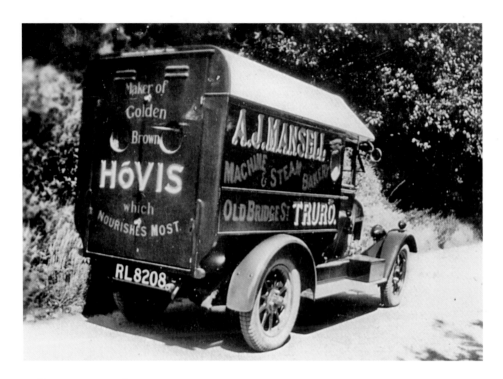

Golden Brown Hovis

Hovis which nourishes the most is advertised on the back of Mansell's mechanical and steam bakery van the number plate of which would be worth a lot of money today. The Warrens van has electronic buttons to make life easier for the driver who has to deliver to shops around the county.

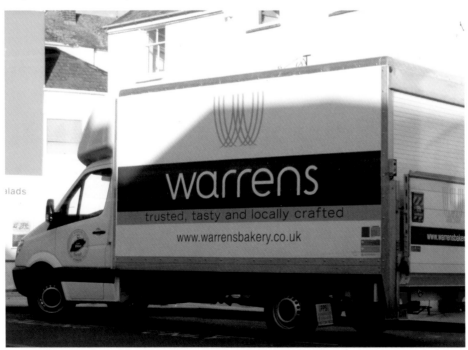

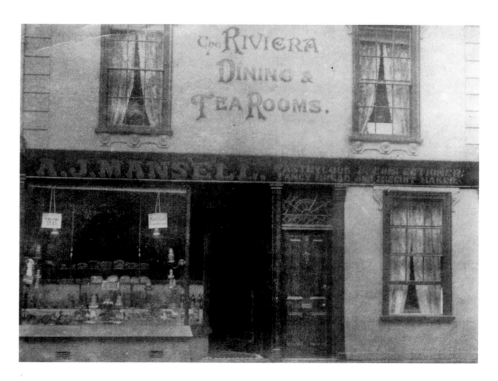

People Need to Eat

People need to eat and enjoy a meal in nice surroundings. For a while during the First World War A. J. Mansell was a confectioner and had the Riviera Dining and Tea Rooms at 3 River Street. There are several cafés in River Street today the most recent being the one in the Royal Cornwall Museum when the gift and bookshop in the area that joined the museum and the former Baptist Chapel was turned into the River Street Café.

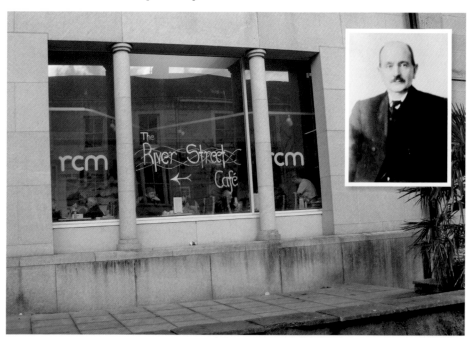

FURNISS
and Company Limited
•
FAMOUS
for
BISCUITS and SWEETS
•
CORNISH
GINGERBREAD
SPECIALISTS
•
TRURO

Gingerbread Factory

The Furniss biscuit and sweet factory was an important part of Truro for many years until the move to Redruth. John Cooper Furniss had started his business during the years when the cathedral was under construction and sold many hundreds of pasties to the hungry builders. When he moved his premises to New Bridge Street, it was the highlight of many a child's school year to visit and see the biscuits and boiled sweets being made and sample the wares. Today the Sunley Orford flats are on the site of the old factory.

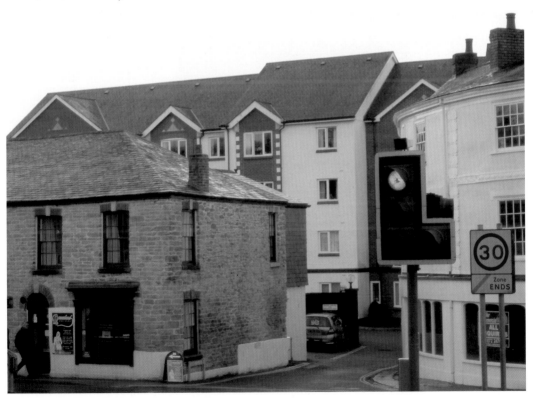

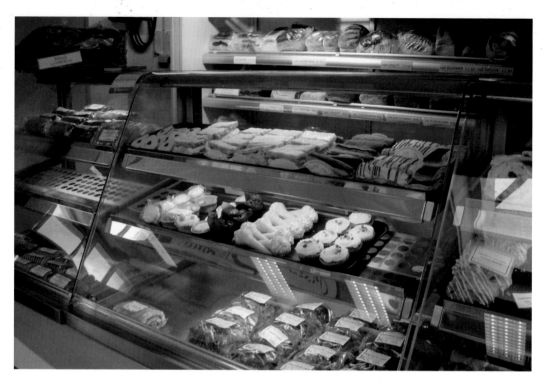

Food Glorious Food
The wares for sale in Martin's Bakery in the Pannier Market look very tempting indeed, probably unheard of delights for the customers who bought their bread from Mr Mansell's van.

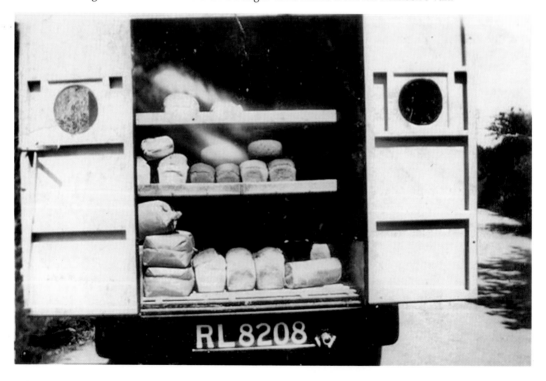

Gingerbreads and Humbugs

These days one can have a pleasant walk through the area known as Furniss Island and see the Sunley Orford Flats occupying the site where once there was Furniss' biscuit factory. Everyone in town knew what was cooking in the factory by the aroma, peppermint rock, humbugs or maybe gingerbreads or fairings. The older photograph shows low tide and lots of mud around Furniss' Island where Mr Peters kept his chickens.

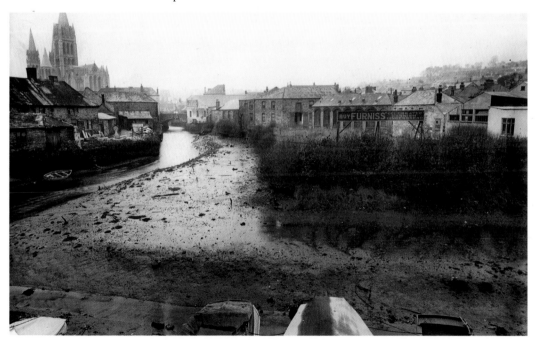

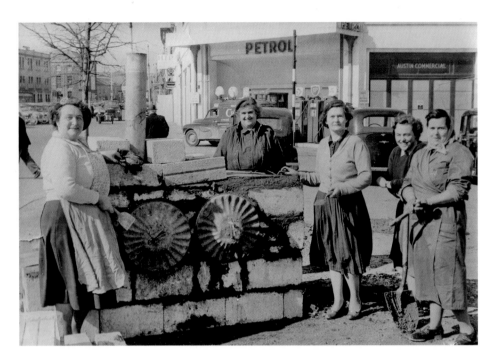

Al Fresco Meal

In 1956 members of the Truro Emergency Feeding Team built a double oven on Back Quay. This was a Womens' Voluntary Service and Civil Defence recruiting effort. Behind the oven is Mrs L. Leach, the instructor and emergency feeding officer for Truro. A similar oven at Strangways Terrace cooked stew with dumplings and vegetables, fruit pudding, jam tart, custard and tea. In warm weather the Stars Restaurant and the MI Bar set up their outdoor tables for their customers.

For Sale by Auction

In March 1839 the property of a Mr John Mansell was advertised for auction. He is believed to be an ancestor of A. J. Mansell who was a baker in Truro for many years. An auction is still a popular event and in February 2010, the television programme *Flog It!* came to Truro. Many people queued for hours in the cathedral to receive a valuation on their antiques, some of which were chosen to be sold at a televised auction.

Household Furniture, Brewing Utensils, Horse & Van, &c.
FOR SALE.

MR. TIPPET,
WILL SUBMIT TO PUBLIC

AUCTION,

ON WEDNESDAY, THE 13th DAY OF MARCH INSTANT,
AT THE
At Two o'clock in the Afternoon precisely,

DWELLING-HOUSE OF Mr. JOHN MANSELL,
No. 2, FRANCES-STREET, TRURO,
THE FOLLOWING

ARTICLES

VIZ —

Elliptic and other Bed-steads with Hangings, Feather Beds, Wash-stands, several Tables, and Chairs; new Iron Furnace 105 gallons, with brass cock, Cooler, Mash-kieve, Beer Horses, several half-hogsheads, small Barrels, Pewter Measures, Glass and Earthenware, &c., &c.

AND ALSO, AN EXCELLENT

HORSE & VAN.

The Auctioneer particularly recommends the above to the attention of Innkeepers, Retail Brewers, Carriers, and the Public in general.

For Particulars, apply to the Auctioneer.

DATED MARCH 1, 1839.

E. HEARD, PRINTER, &c., BOSCAWEN-STREET, TRURO.

Beer house requirements for sale, Francis Scott, 1839.

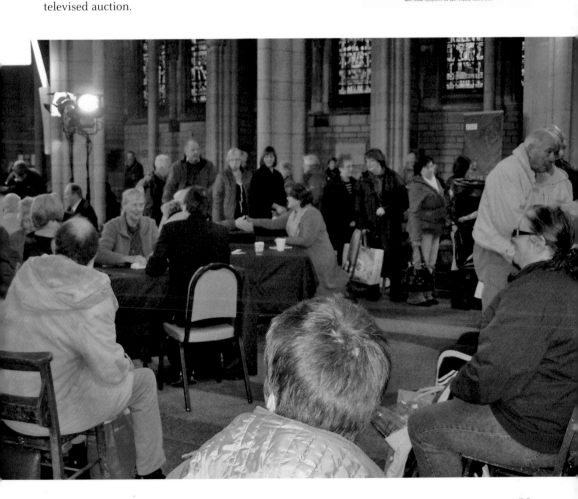

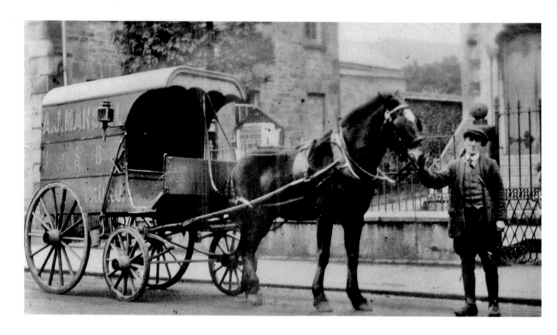

Animals in River Street

One wonders what the horse that pulled Mr Mansell's bakery van would make of one of 'Jack's Cows' that was on display outside the museum in River Street for several months in 2009. This cow was beautifully decorated with wild animals, even more traumatic for the horse to deal with!

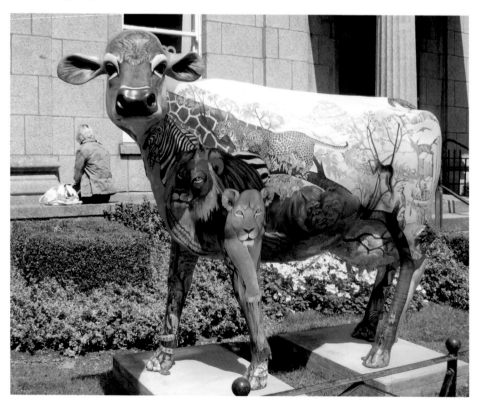

Community Spirit

Steve and Gus are members of the Railway Club and pose outside the old part of the building that was once the stables. In 1945 the residents of Dobbs Lane, Hillcrest Avenue and Sunningdale paraded to what is now the Railway Club for tea. The lady in the front wearing a hat is Mrs Russell of Bosvigo House with her daughter Mrs Hall beside her. The baby in the pram festooned with union flags is Roger Stearn.

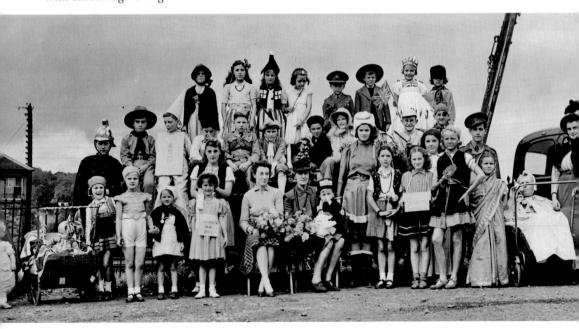

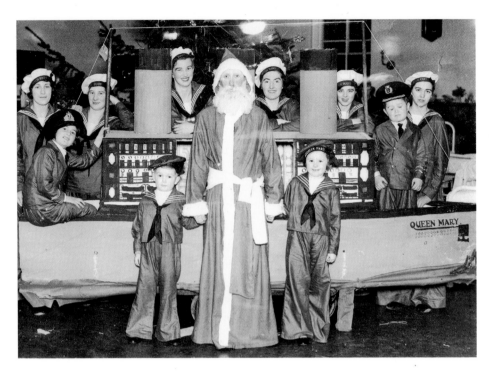

Ho, Ho, Ho!

Merry Christmas, but what a difference in Father Christmas! On 2 January 1935 he is looking rather thin after all his Christmas exertions. He is in the children's ward at the Royal Cornwall Hospital and among the group is nurse Mildred Harvey. In 2009 Father Christmas is in Victoria Square about to set off with his reindeer on a tour of Truro on the first late night shopping evening.

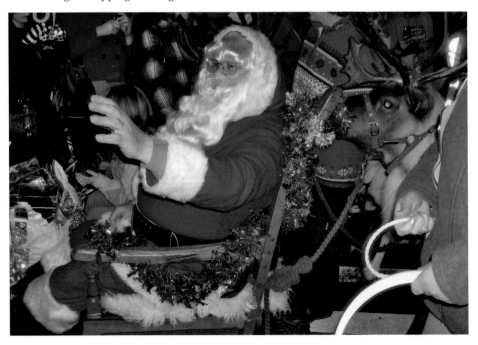

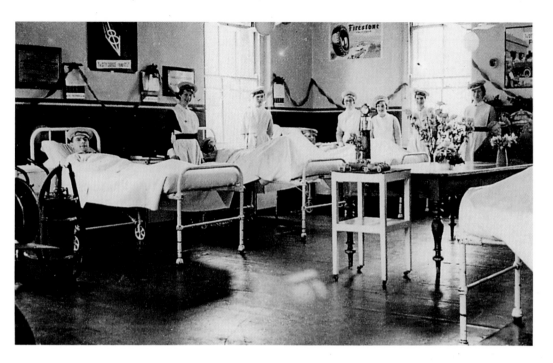

Changes at the Hospital

Patients at the City Hospital in the children's ward were snapped *c.* 1934 with the ward decorated as a garage. The staff then would probably be amazed at the hospital today. With the City Hospital closed and Treliske the main hospital for much of the county the sheer size of the complex is so different. The entrance to the Accident and Emergency Department not only has ambulances regularly arriving but the helipad is also close by.

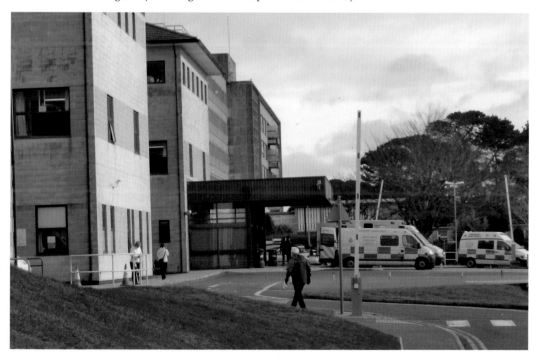

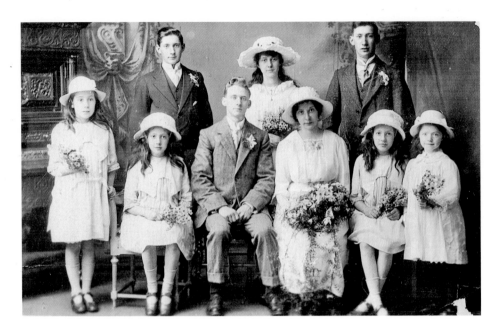

Wedding Day in Truro

The wedding in 1920 is of Jessie Truscott and her bridegroom, Will Skimins. Ernest Truscott is at the back with Frank Truscott and in the front is Olive Truscott with twins May and Kitty Truscott but over time the other names have been forgotten. This wedding probably took place in the Baptist Chapel in Truro. These days many weddings take place in the Register Office at Dalvenie House and the attractive Victorian room is often in demand.

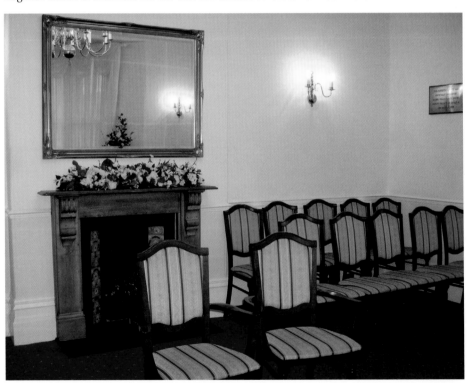

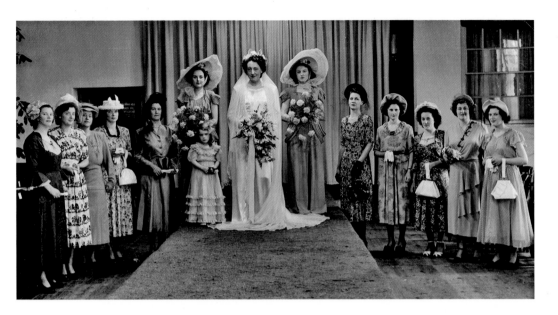

Here comes the Bride

The department store of W. J. Roberts often held fashion parades and this one from the 1950s is dedicated to those special outfits required for a wedding. Somewhere that has seen many brides and wedding fashions is the hallway of Dalvenie House as nervous couples and their families have prepared for their ceremony. The beautiful glass door of the Register Office has been an attractive backdrop for many photographs.

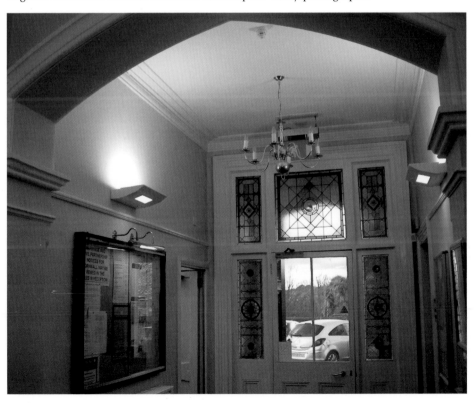

That's Entertainment

Entertainment comes in many forms and this photograph of Jack Warner opening the City Hospital Fête was an opportunity for many people to see the star of many films and of the television series *Dixon of Dock Green*. The roundabout provided fun for the children when Lord Falmouth opened his grounds at Tregothnan for charity on Mothering Sunday 2009.

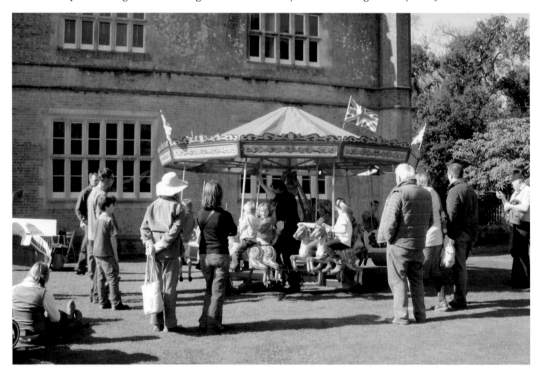

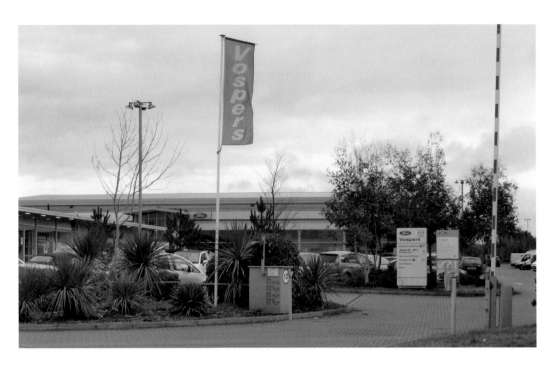

Works Outing

The flags are flying at Vospers the Ford dealers at Treliske where they have smart new showrooms. The group in the photograph c. 1950 are the staff of Truro Garages which became Vospers after various changes. The staff look very cheerful in this slightly lopsided photograph that seems to have been taken outside a public house but the sign over the man marked with an X (George Phillips) advertises afternoon teas so perhaps this is what they came for!

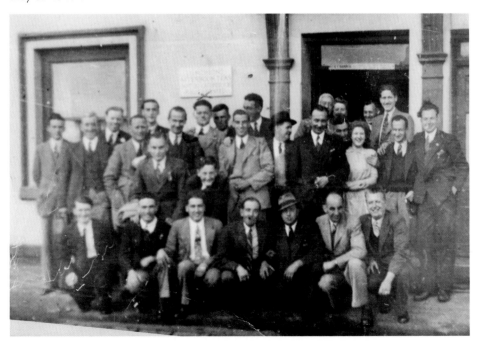

The Swan

Charity night at the Swan *c.* 1961 was the night just before Christmas when the pile of pennies that had been collected and stacked on the bar were pushed over and counted. The money bought presents for children in hospital. Caroline Brown is enjoying watching her father Hubert shoving the pennies and the customers look fairly confident that they will catch them all. The Swan is still thriving in Bosvigo Road and regularly has a new coat of paint.

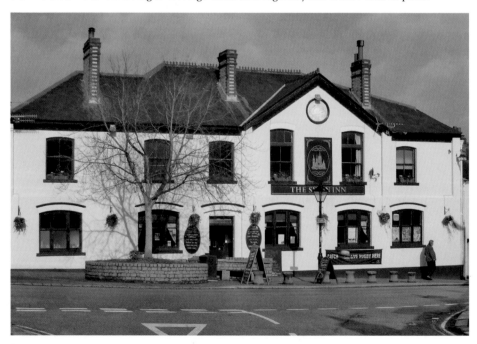

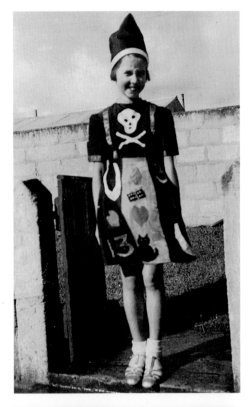

Black Magic and Red Hot
Valerie Penny is dressed in magical signs and symbols to take part in the Victory Parade organised by the residents of Tresawls Road and Highertown in 1945. In 2010 Clarice Mortensen Fowler is dressed as 'The Lady in Red' to sell tickets for a raffle to raise funds for the carnival. The prizes are her home-made pasties. Ninety-three year old Clarice is regularly to be seen in fancy dress as she helps to promote various charities.

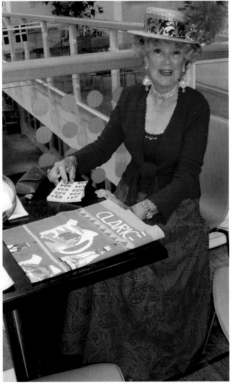

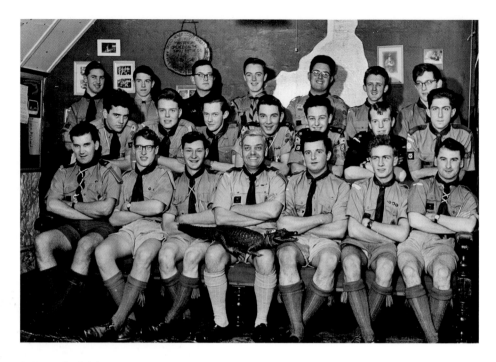

Leisure Activities

Truro (Lander) Rover Scout Crew in the early 1960s. Top row Tony Shingler, Nigel Terry, Keith Briggs, Bill Haynes, Colin Briggs, Peter Cox and Andrew Lynher. Middle row, Kingsley Berryman, Mike Cooney, Colin Hankin, John Hawkey, Philip Carter, Richard Penrose and John Eddy. Bottom row, Brian Pascoe, Ralph Fisher, Keith Goldsworthy, Squadron Leader Frank Terry, Barrie Eslick, Chris Webster and John James. The youngsters today are at the Skate Park at Hendra where they can practise their skilful moves.

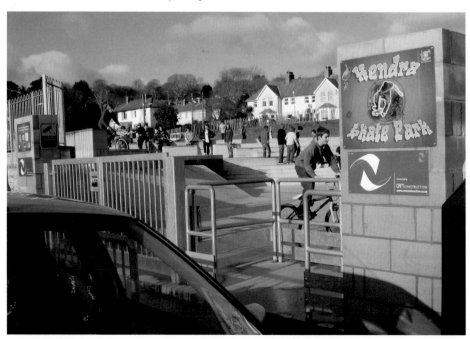

Fun at the Cattle Market
Michael Gibbons (front)
and Christopher James
enjoy themselves at the
old cattle market in 1984.
The cattle market was
built on the site of the
castle which was the seat
of justice in the twelfth
century. Today it is the
site of the Law Courts
meting out justice once
again.

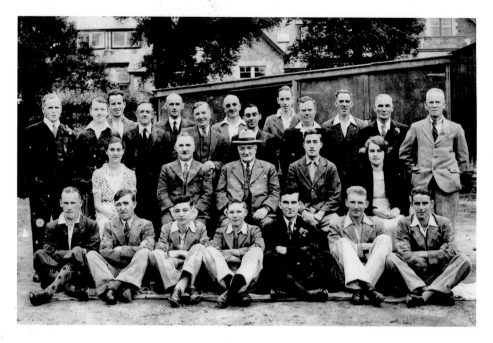

J. H. Pill and Son

The workforce of Mr Pill pose for a photograph outside their premises in The Avenue in 1952 with Mr Pill wearing the hat. The business was described as being 'Builders, General Works including Shop Fitters, Decorators, Sign Writers and Funeral Directors' with addresses also in James Place and Mitchell Hill. The fine house on the corner of Mitchell Hill and James Place, once their offices, still looks smart today.

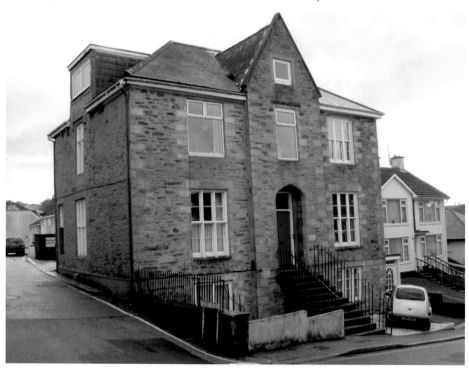

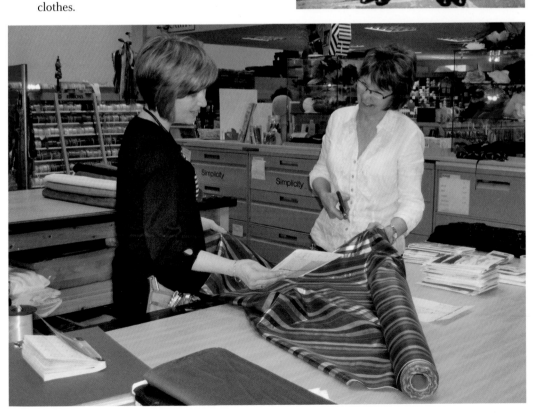

Are You Being Served?

The premises of N. Gill & Son was on Back Quay where later F. W. Woolworth stood. The uniform was a black dress, black shoes and silk stockings. The more senior girls wore a patterned collar. This 1930s photograph has Olive (known as Dick!) Truscott on the left. Today in Truro Fabrics, Louise and Jackie often wear garments that they have made themselves to give customers an idea of what various fabrics look like when made into beautiful clothes.

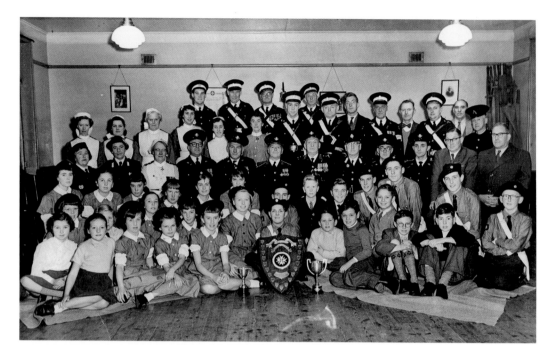

St John Ambulance Brigade *c. 1958*
The St John Ambulance Brigade met in Princess Chula House in City Road. Names that can be recalled include Marlene Cocking-Jose and Susan Phillips (fifth from left, front row). George Phillips with corporal stripes is in the back row and Mr Mutton the butcher is in the middle row. The lady top left is Leonie Mitchell. Today the building is no longer home to the brigade but was opened as a Uneeka home store in April 2010.

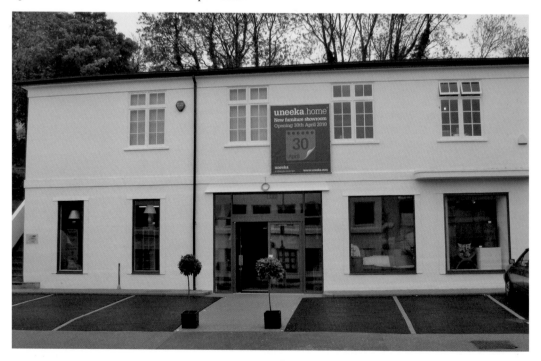

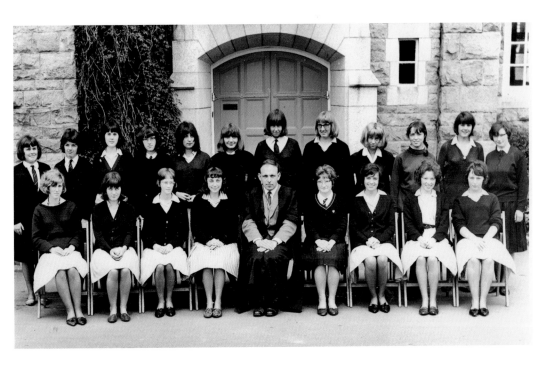

The School and the Supermarket

The girls of class 3B 1961 at Truro County Grammar School for Girls with teacher, Mr Hobba. The back row includes Sheila Davey, Cynthia Crapp, Linda Thomas, Sandra Pearn, Mary Austin, Janet Piper and Sheila Thomas. In the front row are Susan Phillips, Susan Andrews, Barbara Dash, Jenny Hobbs and Margaret Shaw. Unfortunately not all the names can be recalled. Today the school is gone and Sainsbury's supermarket stands on the site.

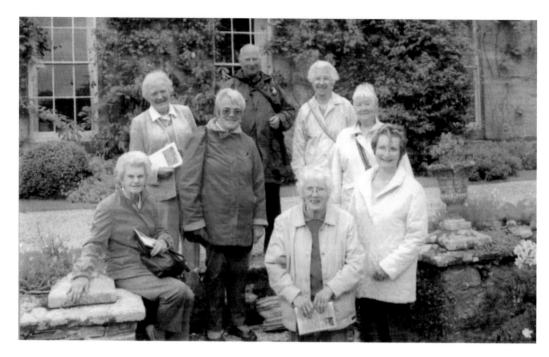

Truro Old Cornwall Society

The society, formed in 1922 honours the old traditions and visits some of Cornwall's historic places on the summer pilgrimages. Members are seen here *c.* 2006 at Trist House, Veryan. Back, John James, with from the left, Barbara Olds, Betty May, Deirdre Dare and Lorna Cave. Front Ethelwyn Parker, Joan Steeds and Caroline Jones. The 2010 picture is taken at a winter meeting with Margaret Mitchell and Joan Alwyn at the front and others waiting for the meeting to start.

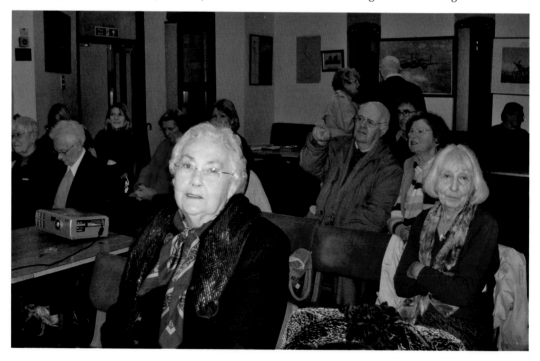

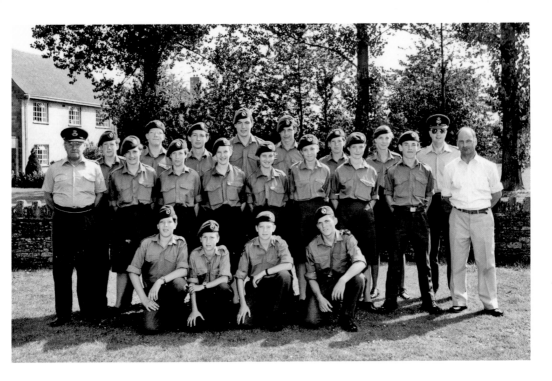

Cadets, Then and Now

In 1976 Truro Air Training Corps (730 City of Truro) Air Cadets posed for a photograph lent by John James. Included in the picture are back row with spectacles, Richard Eslick. Flight Lieutenant Gary Milner and John James are on the right of the middle row and Christopher James is second from left in the front. Major Vaughan Magor photographed Cornwall Army Cadet Corps, The Rifles marching through Truro on Armistice Day in 2008.

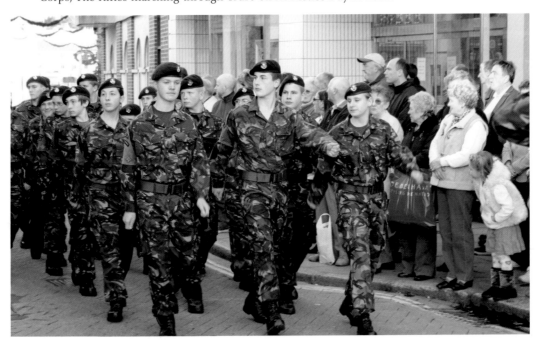

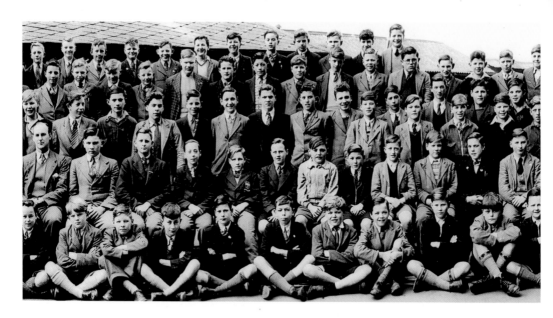

School Photograph

This part of Truro Secondary Modern Boys' School photograph of 1952 includes in the second from the back row, Richard Pellow, Derek Tonkin, Bernard Matthews and Ivan Nicholls. David Job is in the third row. The art teacher Jack Baron, John Warne, David Lamin and John James are in the fourth row and in front are Clifton James and Alan Kendal. The building is now the library. The youngsters of secondary school age now attend Truro College at Maiden Green.

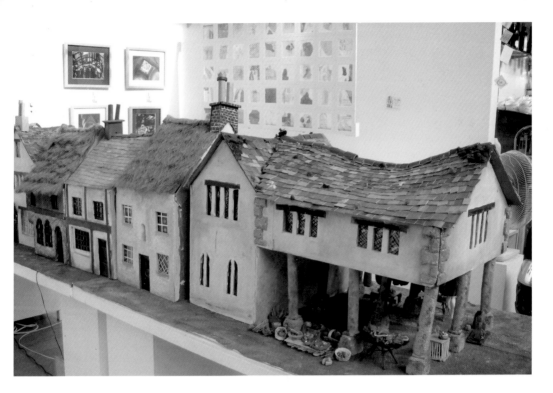

Schooldays

Today's students made a model of Middle Row for the Truro Schools Art Exhibition. It was displayed with the Truro Historical Project in Lemon Street Gallery. Children of 1956 are from St. Mary's School and include; back row, Terry (Jumbo) Osborne and John Penhaligon. Middle row, Marion Pomeroy, Janice Barnicoat, Paul Churm and Susan Phillips. Front row, Jacqueline Congdon, Jacqueline Murphy, Gloria Greet, Diana Robinson, Sheila Jacobs, Marlene Cocking-Jose, Margaret Heddon and Judith Solomon. The teacher is Mrs. Best.

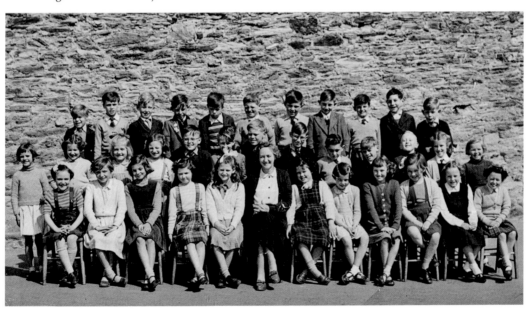

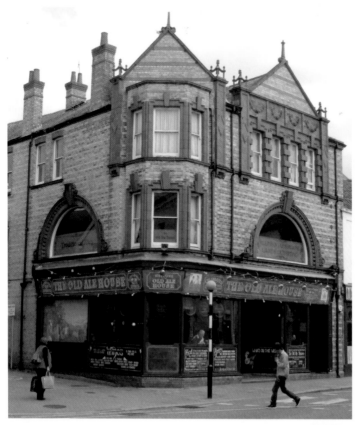

Girls' Day Out

A clue that the Old Ale House was once West End the drapers is in one of the frosted glass windows above the door where 'Millinery, Dressmaking, Ladies Outfitting' is etched. The staff are shown having a day out on the beach in the 1950s. From the back left they are, J. Harris, C. Davis, M. Curtis, P. Raby, F. Lewis, C. Rowlings and P. Venton. Front row, F. Endean, E. Richards, S. Williams, ? Lean and C. Dunstan.

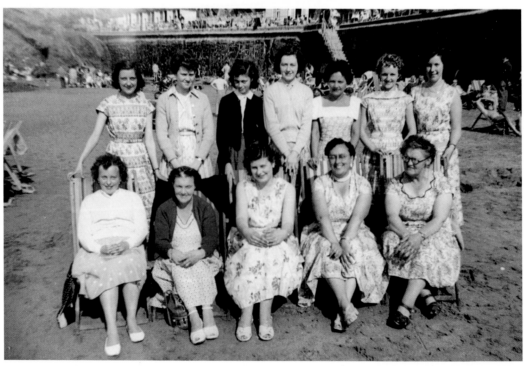

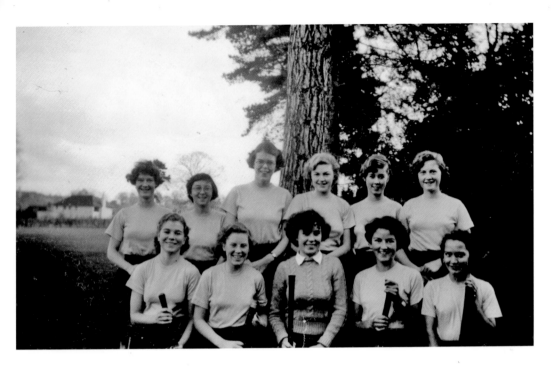

Hockey Players

Cornwall Junior First XI 1951-52. Top left to right, Cynthia Trick, Pat Day, Elizabeth Dean, Valerie Cooke, Valerie Penny, Sheila Lugg. Front row, Margaret Humphries, Mary Pearce, Honour Richards, Mary Mann and Joyce Hope. The team of today are Truro Junior Hockey Club Under 16B team. Back row from left, N. Stevenson, R. Dhumale, B. Wills. J. Rowe, L. Rugg. Middle row, E. Osborne, K. Skuse, J. Lillie, K. Wright, M. Peters. Front row, T. Hockley and S. Montgomery.

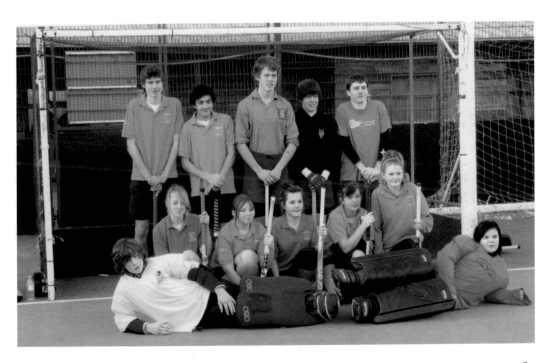

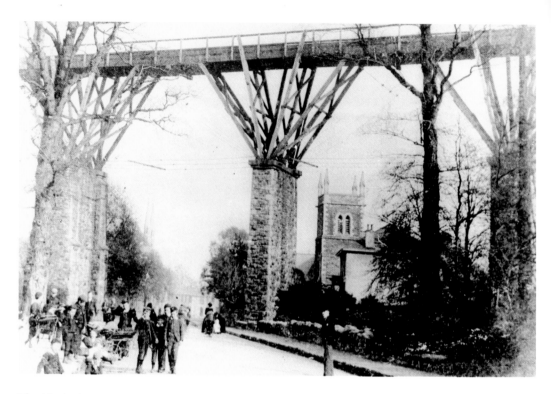

The Viaduct

Brunel's wooden viaduct straddles St George's Road in the photograph of the early 1900s. St George's Church is clearly visible but in the new picture it is hidden behind a tree and the new stone viaduct of 1904 has replaced the old one.

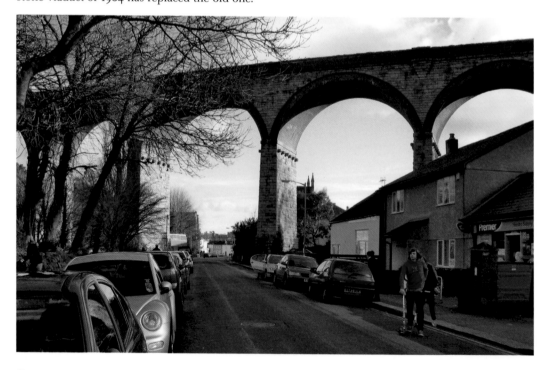

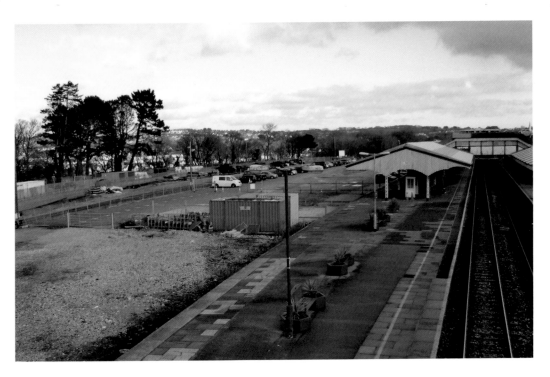

Railway Station

Although Truro railway station still has a down line and an up line with the Falmouth branch line tucked away at the side, what was once extra track for the many passenger trains, goods trains and shunting is now a large parking area for cars.

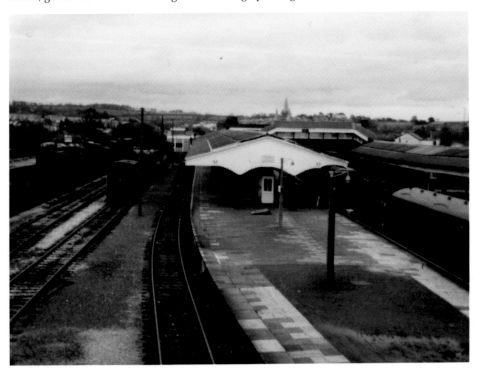

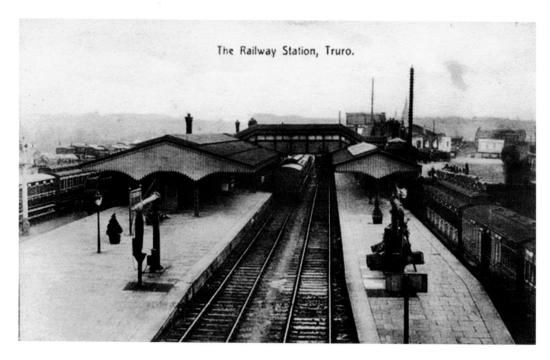

The Railway Station, Truro.

The Train now Arriving

Truro railway station used to have several more tracks and platforms than it does today as well as a busy goods yard and a turntable for the engines. It is rare in having two Victorian footbridges one of which can be seen clearly in the modern photograph. Behind the waiting passengers in the inset photograph it is obvious that the extra lines have gone and cars have moved in.

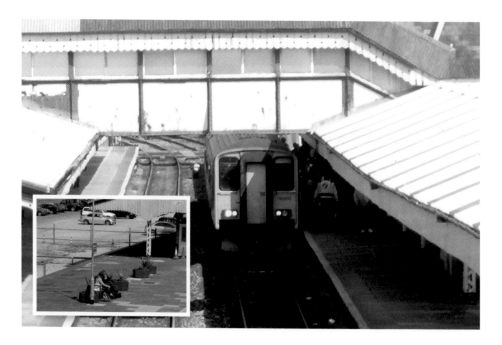

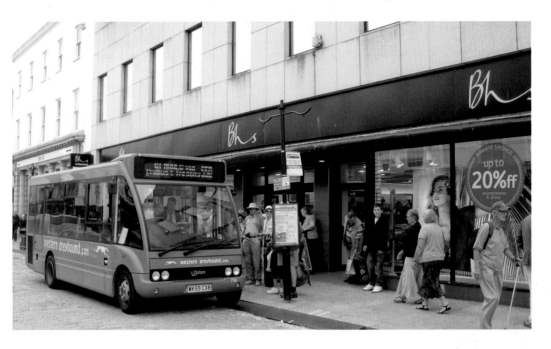

The Carriage of Today

The Western Greyhound is one of several buses that stop in Boscawen Street and rather than take a photograph from the same direction as the 1900 version where we would only see the back of the bus and no passengers, we are looking from the opposite direction. In 1900 the carriages are lined up waiting for the time to return to the villages and are not constantly on the go like the transport of today.

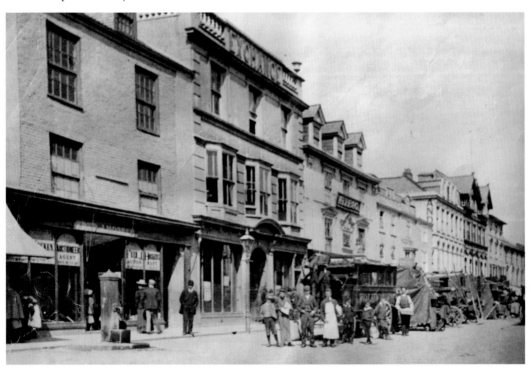

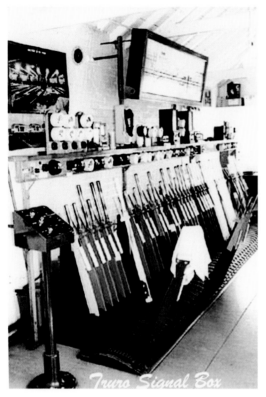

Truro Signal Box

Truro Signal Box

I have been told that the inside of the signal box at the railway station is still the same today as it is in this old photograph. I have not dared to ascend the steps and ask to have a peek inside in case I should cause a distraction! There has recently been an article in the *West Briton* condemning drivers who try to beat the barrier when leaving the station, definitely a risk not worth taking.

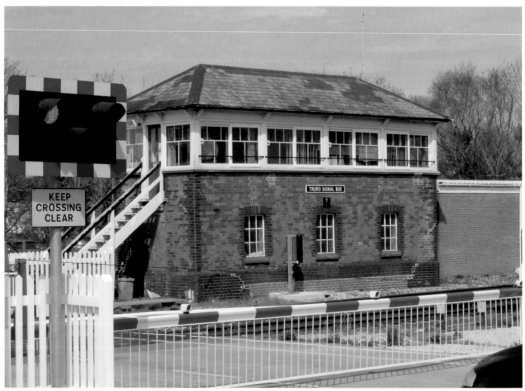

KEEP CROSSING CLEAR

TRURO SIGNAL BOX

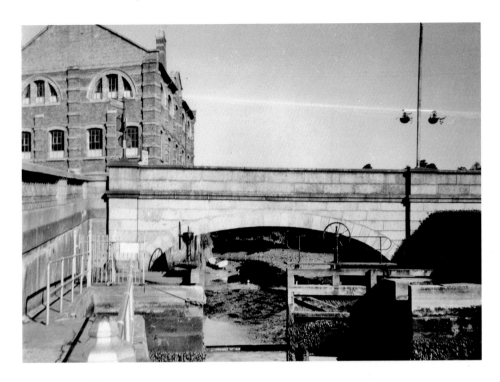

Boscawen Bridge

The 1862 stone built bridge was demolished in the 1960s to make way for the new road called Morlaix Avenue. For many years the bus station was beside the bridge and the green Western National buses were to be found reversed up to the pillars on the left of the old photograph. The modern view was taken from Worth's Quay and shows the new bridge with Haven House beyond it.

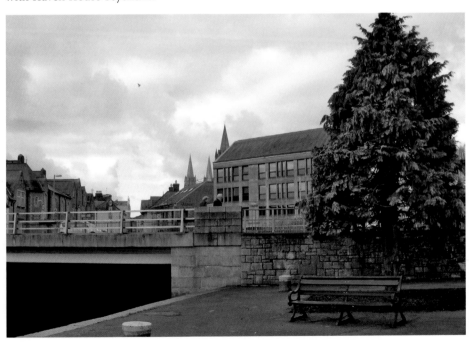

The Leats

In the 1950s it was forbidden to do anything other than walk through The Leats and the park keeper patrolled the area. Today it is much more open and is a service road for some of the shops in Pydar Street as well as a haunt for the occasional skateboarder. In the old photograph the granite slabs that crossed the leat can be seen but the water is completely covered over in this section of The Leats today.

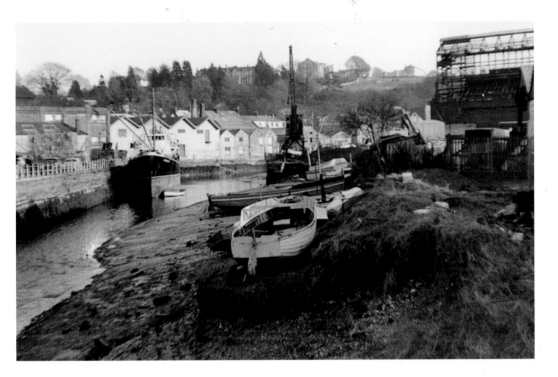

The Riverbank

With the retort of the gas works in the process of being dismantled during the 1960s the river side looks rather messy especially when compared to today. Palm trees line the walkway that runs alongside the bus station and add interest to the area of the new Boscawen Bridge. The paddle-steamer *Compton Castle* needs attention now that it is no longer a restaurant or a flower shop but plans are afoot to rejuvenate that side of the quay.

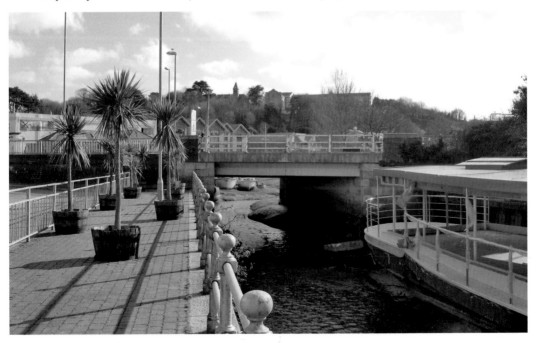

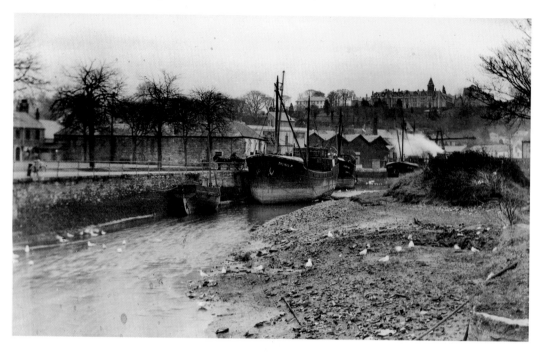

The Green

However attractive the town might have looked when the tide was in it was obviously a different story at low tide beside The Green. It is interesting to see the boats this far up river and note the patient horses waiting to carry the cargo to or from the vessel. Today the buses collect passengers from The Green and the old paddle steamer is awaiting the next phase in its history.

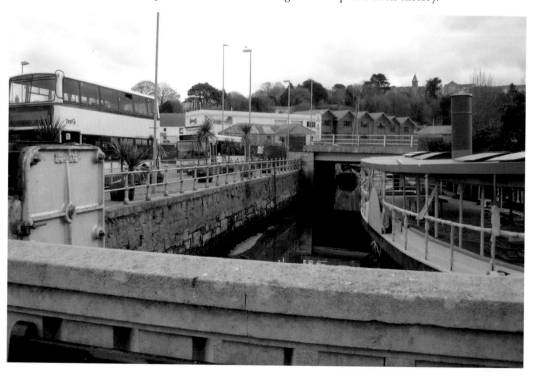

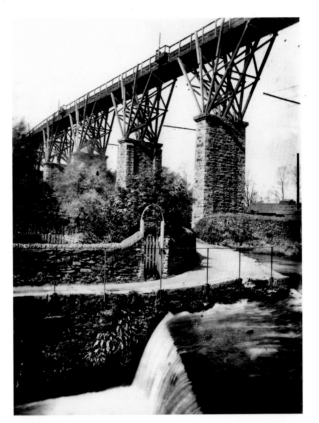

The Waterfall Gardens

Brunel's wooden viaduct has gone
and has been replaced by the
stone structure we know today
but behind the growth of trees the
piers of the old viaduct still remain.
The path through The Leats and
the Waterfall Gardens is still a
popular place although these days
we seem to need far more railings
to stop us falling in the water!

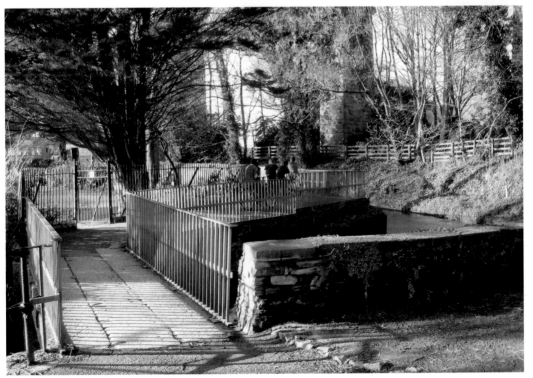

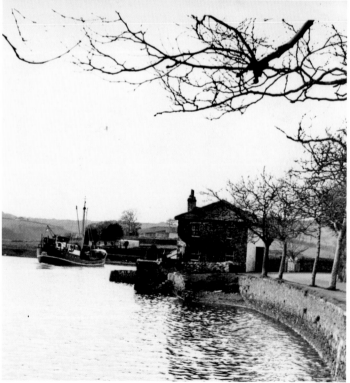

Sunny Corner
The house at Sunny Corner has been a distinctive feature of the river for many years. With its fresh coat of cream paint and a view of all the boats moored nearby it has a cheerful aspect. The photograph from the 1960s shows the steps running down to the water from Miss Kemp's Quay that is presumably named after a lady who once lived there.

Can I Buy Your Mud?
Joseph Henry Williams offered the council a farthing a ton for river mud but the council wanted a halfpenny a ton and the deal collapsed. He had a project in mind and a site earmarked at Point for his factory. He was a clever man and at the time of his death had invented a rock drill but did not have time to patent it so profits went to the crown. We still have plenty of mud in the river!

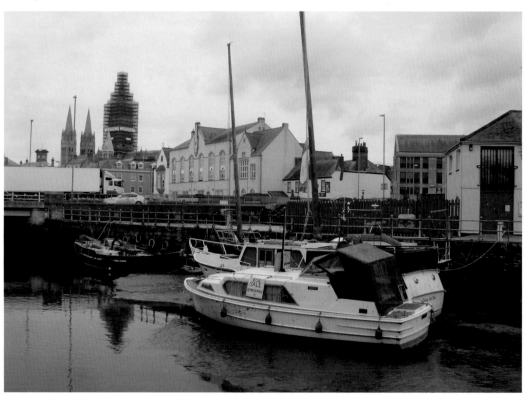

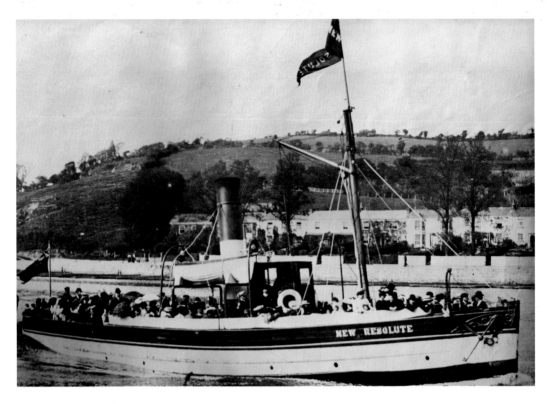

Cruising Down the River

The New Resolute was one of the boats regularly seen in the Truro River. She was taken by the Admiralty for use in the Second World War and never returned to Truro. On a beautiful June morning when hoping to catch a glimpse of a pleasure boat I discovered that boats are like buses, none for ages then two at once. This photograph is of *Enterprise III* as she followed *Enterprise* down towards Falmouth loaded with holidaymakers.

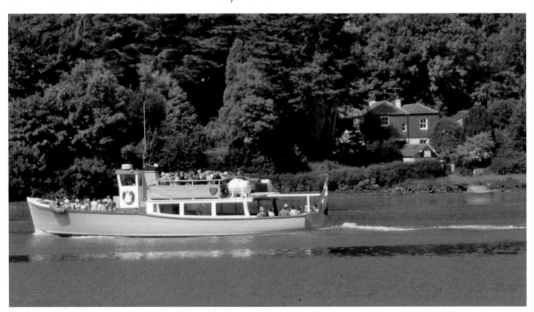